K-SCULPTURE Ⅲ

The Future of K-Sculpture Expanding Globally 2

NOTE

K-SCULPTURE III - The Future of K-Sculpture Expanding Globally 2 is a compilation of columns jointly produced by The Munhwa Ilbo and the K-Sculpture Organizing Committee in 2024. In this collection, twelve of Korea's leading art critics each selected a mid-career sculptor and provided an in-depth analysis of their works. To provide deeper insight into the selected sculptors and their respective works, we have produced video interviews and audiobooks. By scanning the QR codes on each sculptor's page, you can access interviews with all 12 sculptors and explore engaging audiobooks.

K-SCULPTURE III

The Future of K-Sculpture Expanding Globally 2

12 PROMINENT SCULPTORS FROM KOREA

KOH MYUNGKEUN GEUM JOONGGI KIM SEUNGYOUNG BAHK SEONGHI

PARK SEUNGMO SUNG DONGHUN SHIN MEEKYOUNG LEE GILRAE

YEE SOOKYUNG LEE JAEHYO CHA KIYOUL CHOE U-RAM

The Power of K-Sculpture :
Empowering the Future

In the fall of 2024, we published a book that compiles the series The Future of K-Sculpture Expanding Globally, co-produced with The Munhwa Ilbo. Titled *K-SCULPTURE II: The Future of K-Sculpture Expanding Globally 1*, the book features essays by 12 of Korea's leading art critics. They explore the artistic realms of renowned sculptors, including Jeon Yeongil, Kim Jaegak, Park Janggeun, Jeon Gangok, Lim Seungcheon, Lee Seongmin, Kim Seonhyeok, Lee Sangseop, Oh Yugyeong, Shim Byeonggeon, Baek Jingi, and Song Pil.

As we wrap up the year 2024, we have continued our collaboration with "The Munhwa Ilbo," producing the second installment of the series, now compiled into a book. This latest edition, titled *K-SCULPTURE III: The Future of K-Sculpture Expanding Globally 2*, presents critical essays on the works of leading Korean sculptors. These artists, whose contributions have been vital to the contemporary

sculpture scene and who are actively making their mark on the global stage, include Koh Myungkeun, Geum Joonggi, Kim Seungyoung, Bahk Seonghi, Park Seungmo, Sung Donghun, Shin Meekyoung, Lee Gilrae, Yee Sookyung, Lee Jaehyo, Cha Kiyoul, and Choe U-ram.

The twelve sculptors highlighted in this edition represent a significant group of contemporary artists, each driven by an intense passion for their craft. Some gained international recognition even before being widely acknowledged in Korea, while others are redefining the boundaries of sculpture with their uniquely individual perspectives. In their hands, everyday materials take on new artistic life — soap has been sculpted into striking forms, while mechanical components from aircraft have been reimagined as works of art.

At times, photography transcends into the realm of sculpture, while charcoal remnants from burned wood are assembled to form entirely new spaces. Each of these works exudes a sense of beauty and innovation, bearing the marks of deep artistic reflection as well as the painstaking efforts that brought them to life.

Among the various artistic genres, it is unfortunate that sculpture often remains overlooked by the public. While public sculptures are a familiar presence in our everyday surroundings, they frequently go unnoticed. Yet, when we make the effort to appreciate them, they can reveal themselves to be surprising and enchanting discoveries.

Around a decade ago, we held a sculpture exhibition at Severance Hospital. A patient in a wheelchair, after observing the artworks, remarked, "These pieces give me strength." We truly believe this embodies the "power

of sculpture" and the "power of art." Simply pausing to appreciate a work of art can offer both comfort and a sense of discovery.

Korean sculpture, or K-sculpture, is steadily rising in prominence. Korean sculptors gaining international recognition are actively creating works both locally and abroad. This book was developed to introduce K-sculpture to the global audience and foster a connection with the international art scene. We hope it acts as a compass, encouraging talented K-sculptors to produce exceptional works with inspiration and expertise, and to continue making their mark on the world stage.

March 2025
Yoon Youngdal
Chair of the K-Sculpture Organizing
Committee & CEO of Crown-Haitai Group

TABLE OF CONTENTS

ROOT

A Worldview of Nature, Living Creatures, Harmony, and Coexistence
Lee Gilrae

Lee Gilrae's work is moving toward a more fundamental exploration. While highlighting the preciousness, wonder, and archetypal significance of nature, it stands out for its strong pursuit of a depth that goes beyond these explicit aspects. The interplay between the stone that maintains against time and the root that adapts to time reflects the artist's belief that true harmony and balance in nature can only be realized through coexistence.

Hong Kyounghan / Art critic & curator

Lee Gilrae gained early recognition as a contemporary artist, particularly for his Lost Castle series (1988-), which explores the hidden currents of a materialistic society, including the erosion of humanity. Keenly aware of the gradual disappearance of certain aspects in an ever-accelerating world, he shifted his focus to the essentials. Through a process of continuous deconstruction and boundary-pushing, he ultimately forged the unique artistic language he is known for today.

Lee Gilrae's artistic sensibility, developed by his encounters with nature, is deeply grounded in experimentation with materials and substances. Working with diverse elements — including clay, iron, seashells, snails, and pottery fragments — he has delved into the cyclical and interconnected essence of the natural world. His interdisciplinary and boundary-pushing approach, which even extends into archaeology, has played a crucial role in shaping his current work, allowing him to transcend traditional sculptural frameworks.

His recent work resonates with the Gaia theory proposed by environmentalist James Lovelock, which perceives the Earth as a unified organism. The term "Gaia," rooted in Greek mythology and meaning "goddess of the Earth," represents the planet as a whole. This hypothesis suggests

Pine Tree With Three Root 2015-1

Copper Welding / 250x193x150cm / 2015

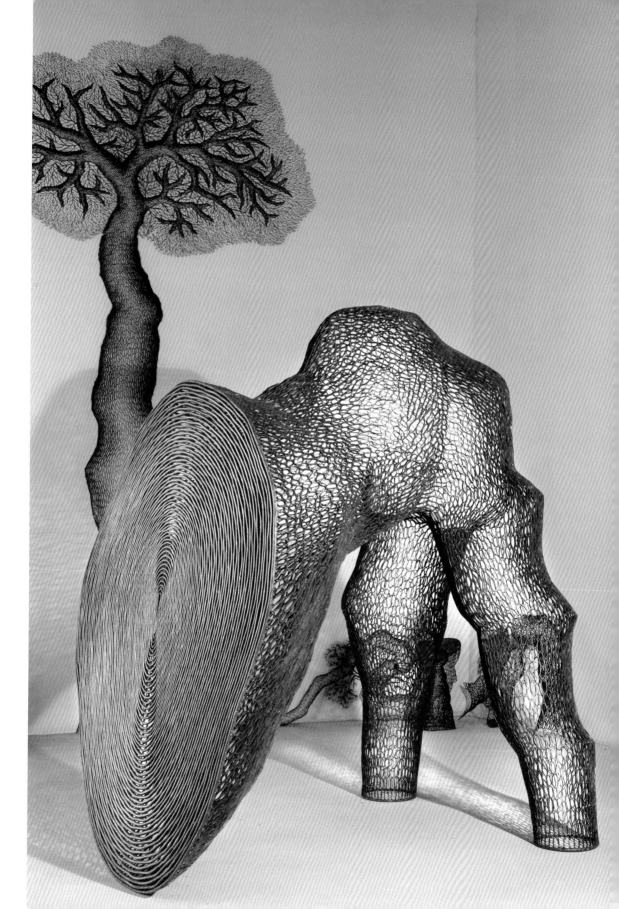

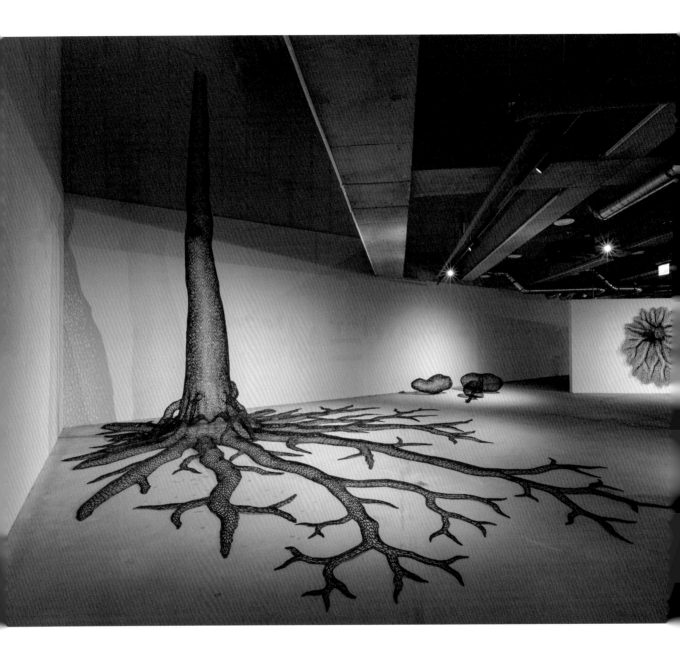

Millennium Pine Tree Root 2023-2

Copper welding /
650x730x900cm / 2023

that all of Earth's environments function as a single, interconnected living entity. His works are closely linked to the concept of holism proposed by critic John Ruskin, who asserts that a whole is more than just the sum of its parts, with each element intricately connected to create a unified entity. They also align with philosopher Arne Næss's perspective, which interprets ecosystems as a model of coexisting consilience.

For them, all living beings in nature have inherent value and are linked within a larger system. This relational and ecological perspective forms the foundation of Lee Gilrae's work, where the natural order of life — distinct and independent in each moment — is seamlessly integrated. His recent large-scale works embody an inclusive and integrative worldview, emphasizing harmony and coexistence at their core. Notable examples include *Millennium Pine Tree Root 2023-2*, presented in his solo exhibition at the Savina Museum of Contemporary Art (January 25–April 21, 2024), and the *Lump 2017* series. These pieces reflect an appreciation for natural aesthetics and the experience of nature while simultaneously exploring the function and role of art.

Exposed roots, a living organism of Indra's net

The themes of inclusion and integration are evident throughout the works. This is exemplified in *Millennium Pine Tree with Three Roots 2019-1*, which resembles the human form, *Pine Tree with Three Roots 2015-1*, where tree rings and roots merge to give rise to a new life form, and the 2015-piece *Roots*, where suspended tree roots challenge the conventional perception of sculpture as a fixed and immutable entity. It is characterized by its ability to dissolve the boundary between abstraction and representation, giving a tangible form to metaphysical concepts.

The artwork *Millennium Pine Tree Root 2023-2* is recognized as one of the artist's defining pieces. This grand depiction of a pine tree captures the essence of the "pine tree" through both its form and the symbolic meaning of the "Geumgang" pine. The artist's unique method, which utilizes diverse copper pipes to mold elements of nature, is prominently displayed in this work. The countless copper pipe "rings" woven throughout the work serve as objects connecting the resonance with nature and the artist's relentless journey of creative practice.

Millennium Pine Tree With Three Roots 2019-1

copper welding /
190x340(h)x80cm / 2019

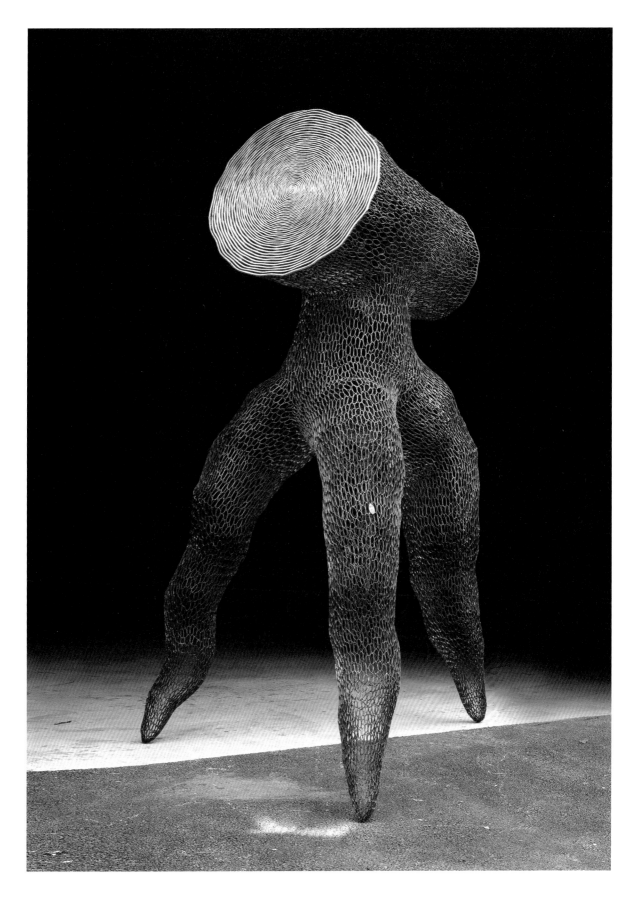

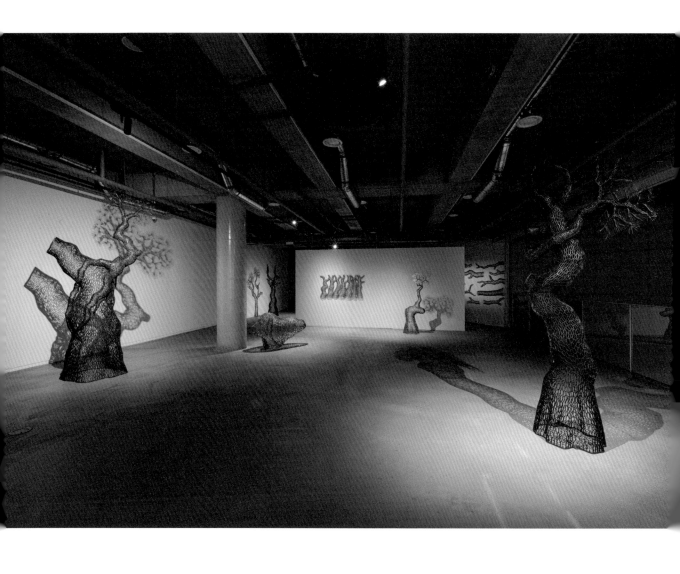

The exhibition view at the Savina
Museum of Contemporary Art

2024

Cells, the fundamental building unit of life, serve as the foundation of all living organisms. Through a process of interdependent aggregation, they gradually evolve, eventually forming the rough bark of a pine tree and uniting into a huge, singular structure. The small cells (rings) are intricately linked, creating a living entity, while the organism (the tree) emerges as a structural manifestation of cellular aggregation.

Cells do not merely vanish within the interconnected microcosm; instead, they evolve into a self-transcending entity. Every being in the universe is intricately related, creating an endless web of interpenetration, where all existences are seamlessly integrated, much like the interwoven structure of Indra's Net — a Buddhist symbol representing the boundless network extending across the palace of Indra (Śakra), the celestial sovereign.

The pine tree carries a rich, multi-layered symbolism. Like its counterparts, *Millennium Pine Tree Root 2023-2* embodies the passage of time, resilience, and the continuous cycle of life. Positioned between the earth and sky, it serves as a spiritual bridge, transforming its serene nature into a symbol of peace and tranquility. Its towering trunks, exceeding 600 meters, metaphorically stand for "wisdom and idealized existence," reflecting the depth of experience and the discernment that comes with age.

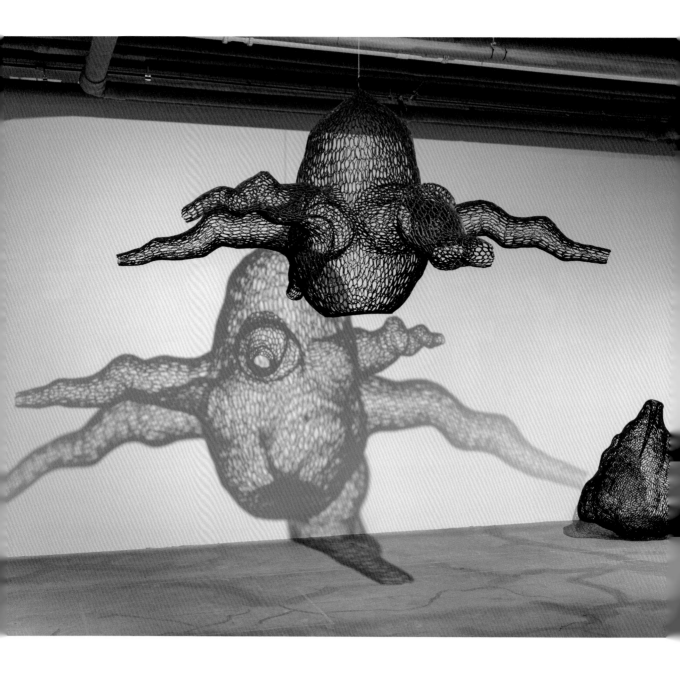

Root

Copper Welding /
115x265x255cm / 2015

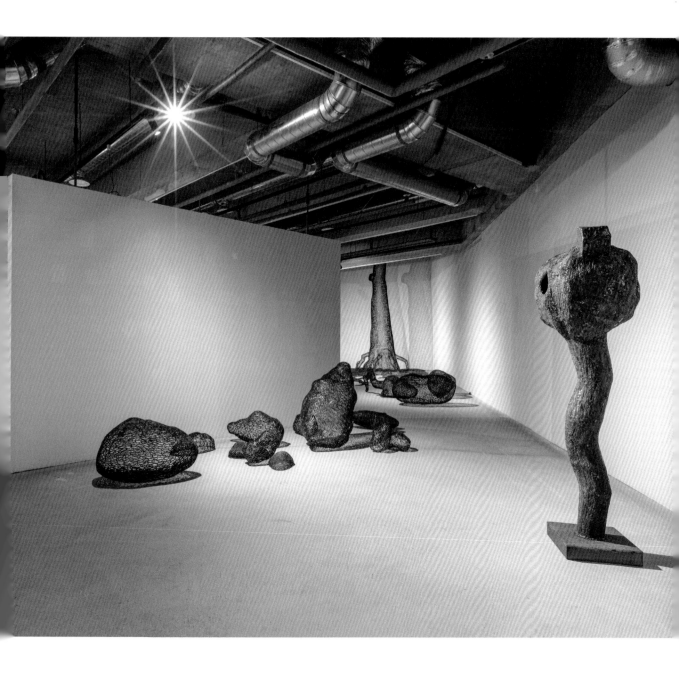

Lump

Iron Welding /
190x60x50cm / 2017

The enduring pine tree, much like the long-lived Bristlecone pine, represents perseverance and a rich historical legacy. Often linked to traits such as steadfastness and patience, the pine embodies intellectual and emotional depth that resonates uniquely with Koreans. These attributes are inseparable from a heightened awareness of environmental crises that span across generations.

What makes the aforementioned works and series even more special is the "root." The root as a metaphor is imbued with the essential principles that serve as the foundation for both nature and human existence. Though hidden from sight, it sustains all life as an unseen yet vital force. It drives the natural cycle of birth and decay, growth and renewal. As it extends and intertwines with other roots, it also reflects the complex connections within human society and ecological systems.

While he has created many works featuring pine trees, it is only recently that the hidden, unseen roots beneath the surface have come to the forefront. Revealing the invisible marks a shift from the eye to the mind. Personally, I see this as an entry into a deeper realm of thought, beyond simply representing objects, and an expansion of aesthetic awareness. This example illustrates that art should not just depict an experience, but be an experience in itself.

All existence merges into one

Recently, Lee Gilrae's work is moving toward a more fundamental exploration. While highlighting the preciousness, wonder, and archetypal significance of nature, his work stands out for its strong pursuit of a depth that goes beyond explicit aspects. This reflects Lee Gilrae's enduring exploration of the relationship between nature, art, and aesthetics. The artist's profound concern is clearly reflected in works such as the *Millennium Pine Tree Lump* series and the *Root* series. These pieces either sculpturally represent rocks and pine tree roots or illustrate multiple smaller roots branching out from a single one. Some of these roots hover in mid-air, while others are dispersed across space. The fusion of stones against time and time-bound roots symbolizes the artist's belief that true harmony and balance in nature can only be achieved when these elements exist together.

The philosophy is presented not as a separate discipline but as a hybrid that blends with artistic genres through continuous grid patterns and intermingling. It is both unusual and unique. This seamless form opens up space for a wider scope of thought.

As boundaries fade, imagination grows stronger, expanding the horizon of thinking. These works, reflecting a clear expansion of aesthetics, stem from animism — the belief that all beings have energy and soul — merged with the artist's sensitivity and "emotional thinking." From this foundation, the pine tree, symbolizing the filling out of emptiness, and "synesthetic sculpture" were brought to life. This process effectively demonstrates how the intangible rhetoric within the artist's mind can be translated into visual art.

The pine tree represents a synthesis of both action and inaction. It encapsulates the processes of creation and destruction, yet exists as a space that is absolutely and always present, transcending the cyclical nature of life and death. In this space, nature and humanity are interconnected. Through the artist's meticulous effort, all forms of existence merge into a unified whole. Lee Gilrae now directs his attention not to the external appearance of representation, but to what exists beneath the surface. As a contemporary artist, he concentrates on the questions of what needs to be done, why, and how — exploring ways to define his own identity and convey the distinctive aesthetic values of our culture. At the heart of this vision lies "The Future of K-Sculpture Moving Toward the World." ⓚⓢ

A Sculptor Shaping the "Origin of Life" : Lee Gilrae

Planting immortal pine trees in the world using industrial copper pipes.

Q. What inspired you to select copper pipes as your medium for sculpture?

I chose to work with industrial copper pipes because of their unique properties. Copper has a certain softness, and it takes on different hues depending on its coloration. Additionally, the oval and ring-like shape of the pipes reminds me of the texture of pine tree bark, which I found intriguing.

Q. How do you approach your creative process?

I begin by creating detailed and precise sketches, which ultimately serve as the blueprint for the piece. These sketches are then enlarged multiple times, and I use copper pipes to weld the design together. It's a labor-intensive process, which can be tough and challenging, but I believe it's a crucial part of the artistic journey. That's why I willingly endure the hard work. My inspiration comes

from contemplation and thought, as well as from travel and other sources like films and literature. An artist, in my view, is someone who embarks on a journey to discover their path.

Q. What projects are you currently working on, and what are your plans for future exhibitions?
In 2024, I had the opportunity to exhibit at the Savina Museum of Contemporary Art, where my work explored stones, rocks, and roots that extended over 10 meters across the floor of the gallery.

Looking ahead, I see these elements continuing to evolve and grow in my work. While stones and rocks are often seen as lifeless, I approach them differently, viewing them as living entities, or at least in the same context as things we may easily perceive as dead. Just as humans go through cycles of life and death, I see the rhythm of living and dying as an ongoing process that repeats endlessly. This cycle ultimately ties into the broader human experience, continuously evolving and advancing. From this perspective, I regard the Earth itself as a living entity. In 2025, I am scheduled to hold a solo outdoor sculpture exhibition at the Seongbuk Museum of Art, followed by a solo exhibition at Museo Carlo Bilotti in Rome, Italy, in 2026.

Q. What message do you aim to express through the structure of large copper pipe rings?

Everything, whether a living organism or an object, begins at the atomic or cellular level before forming into life and matter. Even the universe itself was born from the merging of dust. Humanity and the Earth exist within this same structure. On a grander scale, this is the very process by which the universe came into existence. Through my work, I seek to emphasize the importance of preserving the natural world and environment we have inherited, ensuring it is passed down to future generations in its entirety.

Please scan the QR code to watch the sculptor's interview video.

Who is Lee Gilrae?

Lee Gilrae, born in 1961 in Yeongam, Jeollanam-do, majored in sculpture at Kyung Hee University and continued at its graduate school. Since his debut solo exhibition in 1991, he has held over 15 notable solo exhibitions and participated in invited thematic and group exhibitions, including at the Savina Museum of Contemporary Art and the Opera Gallery in New York.

Lee Gilrae's ingenious works swiftly attracted the attention of critics, earning prizes such as the Dong-A Art Award at the Dong-A Art Exhibition (1990) and the Artist Award from the Korea Art Critics Association (2015).

His art pieces are housed in numerous esteemed institutions, including the National Museum of Modern and Contemporary Art, the Seoul Museum of Art, the Samsung Foundation of Culture, and the Pohang Museum of Steel Art.

The word that best describes Lee Gilrae is freedom, unbound by traditional constraints. Though he is often referred to as the "pine tree artist," this title was not one he sought; it was given to him naturally. If there is any aspect of the pine tree reflected in him, it is the resilience that allows him to endure the challenging process of his work, unaffected even in the face of the harshest storms.

FEMALE

An Art of Transcendence Woven with Female Narratives
Yee Sookyung

In the process of forming a complete form by intertwining and leaning on each other,
there is a sense of affection for reconciliation rather than conflict and coexistence
rather than exclusion. Yee Sookyung's work world, which harmonizes men and women,
crosses East and West cultures, and crosses art and crafts,
contains a real feminist world view that values humans and all things.

Kang Eunju / Art critic, Art historian

Women wearing wide, billowing skirts line up and perform a dance in ensemble. Their hair, adorned with elaborate jewelry, rise up like the spires of temples or the shapes of flames, below which faces of young girls, innocent and youthful, sit as if in prayer. They are Princess Bari, Guseul Halmang, Tara (a female bodhisattva in Tibetan Buddhism), and at the same time, The Virgin Mary. In her 2021 exhibition *Moonlight Crowns*, the artist Yee Sookyung selected these women from both Eastern and Western religious and mythological narratives and depicted them as a sort of deities, arranging them to present a scene where they cluster in solidarity. A year later, in her twenty-ninth solo exhibition, she named them *'Intimate Sisters'*. Here, the term 'intimate' conveys a feminine attitude of affection and 'sisters' implies solidarity among women.

While Yee Sookyung is well-known for her *Translated Vase series* (2002-present), her work has long delved into themes of women's lives and identities. In her first solo exhibition, *Getting Married to Myself*, in 1992, she portrayed real-world desires and struggles of women in a cynical manner through a display of photographs in which she played both bride and groom, and glamorous high heels that cannot be worn due to broken strap.

Yee Sookyung belongs to the generation of Korean artists influenced by the extensive influx of Western feminism

Moonlight Crown_
Guseul Halmang

2021 / Glass buoy, brass, iron,
24K gold leaf, wood, 3D-printed
sculpture, pearl, glass, mother-of-
pearl / 134.7x56.4x41.9cm /
Photo: Yang Ian

beginning in 1988. Unlike the first generation of feminist artists in Korea who emerged within the Minjung Art Movement of the 1980s, she embraced feminist art through a more theoretical approach and a diverse range of themes. As she spent her twenties and thirties in the 1990s, her experiences of marriage, childbirth, and parenting brought her to confront the real-world challenges that women face as well as the complexities of her identity as an artist. In her efforts to reconcile these aspects, she naturally wove women's narratives into her work.

In Vases and Crowns, and All Objects, Lies History and Meaning

According to the artist, the *Moonlight Crown* series is described as "works where the crowns have become bodies themselves, too large and heavy to ever be worn on the head." Rather than placing crowns, symbols of power, atop heads, she uses them as pedestals from which fragments of all kinds of objects sprout up like plants. As a result, the crowns embody the female figure, as well as the image of a deity. Their surfaces are covered with iron, bronze, glass, mother-of-pearl, gemstones, and mirrors. Also visible are angels, praying hands, crosses, dragons, tigers, and Baroque-style botanical patterns.
These fragments are primarily metal ornament pieces

Polaris

2012 / 3D modeling, 3D printing,
Dimensions variable /
Photo: Courtesy of MMCA

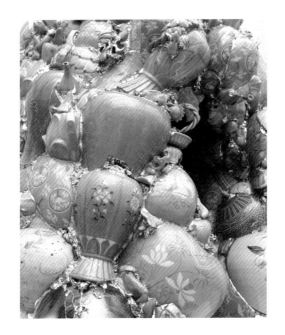

Translated Vase TVBGKSHW 1

2023 , ceramic shards, epoxy, 24K
gold leaf , 196x104x111cm
Photo. Yang Ian. Courtesy of the
artist

used in jewelry that bear traces of old beliefs but are now abandoned and secularized, having lost their original place. They hold a similar meaning to the ceramic shards used in the *Translated Vase* series, which come from ceramic pottery that have been destroyed by master potters because they were deemed imperfect. The artist gathers these discarded objects and shards to create new forms, new organisms. Most of these artworks bloom into shapes rounded at the center and are densely packed with objects, which can be viewed as a symbol of female fertility and abundance, comparable to the Venus of Willendorf or Rubens' Three Graces.

Reflecting on the title, the moon represents a feminine space that shines serenely in the darkness, which stands in contrast with the masculine sun that illuminates and reveals all things. It is also a mystical presence that embraces darkness in its shadows and harbors infinite imagination since the beginning of time. Moonlight, then, functions in Yee Sookyung's artworks as an energy that allows objects to transcend their past wounds and restore their sacredness, enabling them to shine once more.

This very energy serves to resurrect a shattered ceramic pot into a complete vase once more, and empower a forsaken angel to rise above the authority of the crown, reclaiming its spirituality.

Yee Sookyung's creations are predominantly crafted through a meticulous process of expertly controlling and delicately shaping a variety of materials. Her emphasis on craft over traditional sculpture and her technique of weaving together precious gemstones from both the East and West with broken and discarded objects reveals her intent to transcend not only the traditional hierarchies of art but also prejudices of the typical world, while demonstrating her determination to redeem and revive all things beautifully.

Classics of Korean Female Narratives: Princess Bari and Guseul Halmang

Presiding over all of this is the face of Princess Bari. The artist frequently depicts female figures bearing faces of young girls, each of whom can be interpreted as portrayals of Bari, the heroine of the eponymous Korean folktale. Having freed themselves from the grime and struggles of the secular world, they come to signify the idea of purification. Ultimately, through this journey of purification, they become spiritual beings.

Around 2003, in an effort to awaken her senses, Yee Sookyung began creating Buddhist drawings using cinnabar, which led her to explore religious and mythological themes. Among these, the Tale of Bari stands

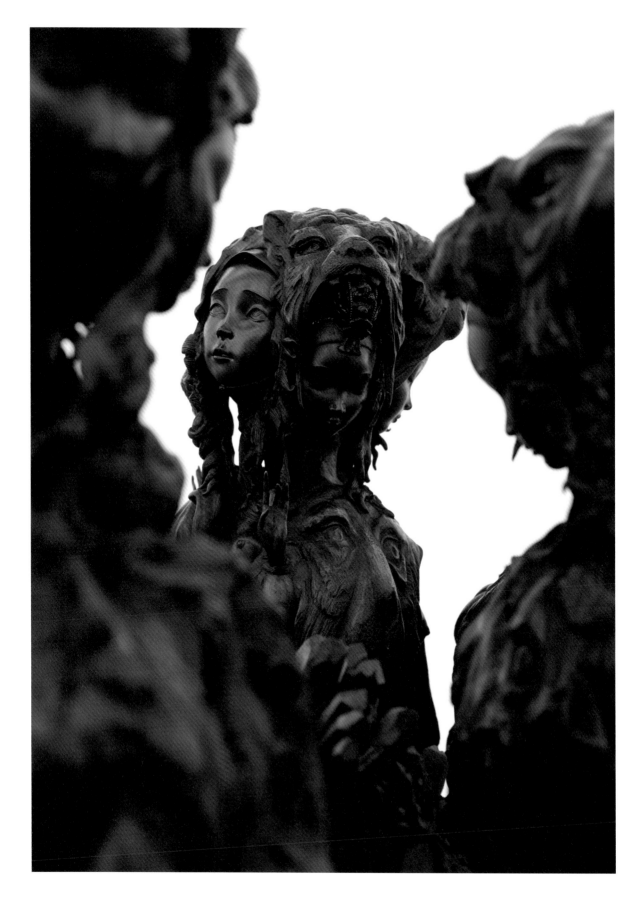

out as one of the artist's longest-standing subjects, first addressed in her 2005 series Breeding Drawing and later more explicitly in her 3D printing work *All Asleep* in 2015.

As the story goes, Bari, abandoned by her parents for being a daughter, embarks on a journey to the underworld to find the water of life in order to save them. After enduring numerous trials, she succeeds in reviving her parents and chooses the fate of becoming a *mudang* (shaman), who bridges the realms of the living and the dead, human and divine, thereby becoming the ancestor of all shamans in Korea. The folktale is regarded as a critique of the patriarchal societal structure and the Confucian ideology of *nam-jon-yeo-bi* (male superiority), illustrated through the life of Bari, who was oppressed simply for being a woman. Likewise, Guseul Halmang, featured in *Moonlight Crown_ Guseul Halmang* (2021), stands as a prominent figure in Korean female mythology. A young girl, abandoned by her parents, encounters a boatman and drifts to Jeju Island, where she becomes a *haenyeo* (female diver). With her exceptional prowess, she harvests abalones and pearls and presents them to the king, receiving multicolored beads in return. Thereafter, she became known as Guseul Halmang (Bead Grandmother) and is still regarded today as the indigenous guardian deity of Jeju, symbolizing fertility and abundance, and bestowing blessings upon her

Moonlight Crown_Intimate
Sisters_East Peak
2021 / brass, epoxy, iron, resin /
114x73x74cm / Photo: Yang Ian
Courtesy of the artist

descendants. While her narrative parallels that of Princess Bari, Guseul Halmang distinguishes herself by actively shaping her own destiny, independent of fate. This legend, which reflects the aspirations of Jeju's *haenyeo* who led arduous lives, is reimagined by the artist using old glass buoys and a 3D-printed head of Bari.

Yee Sookyung frequently incorporates the imagery of hands in her oeuvre, drawing inspiration from Tara, the Tibetan female bodhisattva. Tara's hands, with eyes on their palms, enables her to perceive all human suffering, safeguarding the lives of all beings and guiding them toward enlightment. In *Polaris*(2012), the delicate hands of young girls are portrayed in gestures of embrace and prayer, nurturing both humans and animals. Meanwhile, the women adorned with tiger skins in *Moonlight Crown_ Intimate Sisters* (2021) trace their origins to the tiger tribe from the Myth of Dangun.

The women of the tiger tribe, who were overlooked by Dangun, establish their own kingdom and flourish in infinite proliferation through their solidarity, cooperation, and mutual care among themselves. The assembly of girls, rising by leaning on each other's shoulders and adorned with a myriad of women's breasts embodying the imagery of a powerful maternal deity, epitomizes the formidable strength of female solidarity.

Yee Sookyung's recurrent depiction of heroines from classic female narratives—Princess Bari, Guseul Halmang, Tara, and the women of the tiger tribe—serves not only to illuminate the discrimination and challenges women still face in contemporary society but also to celebrate their strength, resilience, and healing powers in overcoming such adversities.

Affectionate Solidarity: Spirituality Beyond Healing

Yee Sookyung has often been noted for conveying the meaning of 'healing', through her method of filling the *geum*(cracks) in broken ceramics with *geum*(gold). Her recent work on the *Moonlight Crown* series, however, appears to have transcended the concept of 'healing,' reaching a higher realm of spirituality.

The artist recalls that while working on the series, she deeply felt that "spirituality exists equally in all of us." She suggests that all beings are interconnected, and therefore, inherently complete. The *Moonlight Crown* series communicates a profound belief that encourages us to let go of the fears and anxieties of reality, as "we are already complete beings, and our bodies are sacred temples, our spirits the resplendent crowns themselves."

The artistic process whereby broken objects intertwine and rely on each other to form a complete shape

embodies a sense of mutual affection or tenderness that seeks reconciliation over conflict, and coexistence over exclusion.

Yee Sookyung's artistic world, which harmonizes the masculine and feminine, traverses Eastern and Western cultures, and bridges the realms of art and craft, encapsulates a feminist worldview that cherishes the intrinsic value of all humanity and all things.🅚🅢

Photo by Yang Ian

Sculpture that translates Ceramic Fragments : Yee Sookyung

Shaping new life from broken fragments and diverse materials.

Q. How do you interpret the terms "Translated Vase" or broken ceramics?

When I hold a ceramic shard and examine it closely, I see it as a vessel of countless untold stories, much like the long history of ceramics itself. The moment a ceramic piece breaks, it experiences a rupture in time and space, losing its original function and value. However, from a different perspective, the fear of potential breakage disappears, offering a sense of relief. If the piece is a reproduction, it is further liberated from the illusion of authenticity. For this reason, ceramic fragments feel to me like seeds carrying the potential for new life. When I began working on Translated Vase in 2001, I tried persistently to mold them into the shapes I initially envisioned. However, after numerous setbacks, I realized that the process was less about imposing a specific form and more

about approaching the work gently, like assembling a puzzle and naturally connecting the pieces – akin to what matchmakers do. The experience of creating Translated Vase not only transformed my artistic attitude but also profoundly changed my outlook on life. Since 2001, I've aimed to create an organic artistic world that comes naturally. To achieve this, I've continually kept my hands busy with touching, crafting, and drawing. This journey led me to explore materials like cinnabar and practice drawing daily. Gradually, my thoughts and efforts

interlocked like machine gears, driving me with excitement toward unexpected directions. I valued this time greatly, as it enabled me to develop my own distinct technical methods in my work creation. As my mind and body synchronized in the act of creation, my life underwent a transformation. I find myself evolving into someone different from who I was before, and this process is fascinating.

Q. What does your work Moonlight Crown represent?

The *Moonlight Crown* series features crowns that are too large and heavy to wear on the head, transforming them into body sculptures. This series stemmed from questions about the symbol of absolute power: "How is a crown that shines like the sun created, and what hidden truths lie beneath its splendor?" When we look at both Eastern and Western art, we often see halos and aureoles above the heads

of figures like Buddha, Jesus, and various saints. One day, I began to wonder — could crowns have served as replacements for halos and aureoles? In ancient times, those who connected with higher-dimensional realms might have emitted light from their heads, and perhaps early humans were able to see this light with their own eyes. Through the *Moonlight Crown* series, the message I aimed to express is that I am already whole, my body is a sacred temple, and my very energy serves as a resplendent crown. These thoughts come to me.

Who is Yee Sookyung?

Yee Sookyung was born in Seoul in 1963. She received her BFA and MFA in painting from Seoul National University, Korea. She began to gain recognition with her first solo exhibition, *Getting Married with Myself*, which was held in Seoul and Tokyo in 1992. She participated in numerous feminist art group exhibitions, such as *Women and Empty Scene* (1992) and *99 Feminist Art Festival – Patji's on Parade* (1999). Gaining international acclaim with her *Translated Vase* series first introduced in 2001, she expanded the themes of her sculptural work with the *Moonlight Crown* series since 2017. Her unique artistic vision is also showcased in the *Daily Drawing* series, cinnabar drawings created to train both body and mind, and the self-replicating *Rose Painting* series. Yee Sookyung's work has been featured in major international exhibitions, including the 6th Gwangju Biennale (2006) and the 57th Venice Biennale (2017). She has held solo exhibitions at renowned institutions such as the Museum of Contemporary Art Taipei (2015), Museo di Capodimonte in Naples (2019), and Musée Cernuschi in Paris (2023).

Please scan the QR code to watch the sculptor's interview video.

SYMPATHY

The Art of Asking, Sympathizing Sculpture
Kim Seungyoung

Kim Seungyoung's sculptures pose profound questions, delving into the essence of
true selfhood with the inquiry, "Who am I?" They reflect on the existential conditions of
humanity, set against the expansive backdrop of civilization's history and scale.
These works embody a sense of humanity and evoke sympathy. Like a Buddha gently
bowing its head in tears, they quietly stir a deep sympathy for the experience of existence.

Kho Chunghwan / Art critic

KIM WHANKI
DANIEL CRESPY
XAVIER GONZALEZ
ODILE CRESPY
JULIE CRESPY
JULIE CAISSIE
PARK MARI
CHOI SEON JU
AN KYUNG SUK
PARK KYUNGEUN
KIM BORA
KIM JONGMOON
LEE MIN
YU TONGHYUN

Memory 1963-2019

Single channel video, sound design
by Oh Yoonseok / 2019
Installation view at the Whanki
Museum

I have a work by Kim Seungyoung at home, generously gifted to me by the artist. It's a fractured piece of brick engraved with three letters of my name — a one-of-a-kind nameplate. I imagine there are others who own similar pieces, each with their own names etched onto the brick. These works are identical in concept yet uniquely personalized. The artist carefully carves the names of people he has encountered on his journey onto fractured pieces of brick. With these named bricks, he builds a wall — a metaphor for life itself. The use of cracked bricks symbolizes the passage of time, reflecting the marks and scars that life inevitably leaves behind.

Constructing a wall with bricks inscribed with people's names embodies the artist's belief that relationships shape his character and define his identity. This act reinforces the notion that humans are inherently social beings and resonates with the post-structuralist perspective that the self is a composite of others.

One of his works exploring self-identity takes inspiration from the format of movie's closing credits, which traditionally list the names of the cast and crew at the end of a film. However, unlike conventional credits, his work features the names of people he knows displayed on the screen. While standard credits scroll upward from

the bottom, his rendition reverses this motion, with the names descending from top to bottom. Just as raindrops come together to form rivers that ultimately flow into the sea, the artist believes that relationships with individuals collectively shape a person's character.

Sculptures That Ask Questions

Kim Seungyoung's art predominantly centers on exploring self-identity, with a few exceptions. His work persistently raises existential inquiries like "Who am I?" This question appears to have taken root during his formative years, particularly during his time at *P.S.1* (1999–2000), marking the beginning of his artistic journey. During his time at an international residency in the United States, the artist created a work where he wrote the letter "I" (symbolizing the self) in the sand of a desert. As the wind blew, it would erase the letter, and the artist would rewrite it, only for the wind to erase it once more, continuing this cyclical process.

In another video piece, Kim Seungyoung displays a life-size photograph of himself on the wall, only for it to fall to the floor. He rehangs it, and once again, it falls, repeating this cycle. The work raises the question: "Am I in the photograph, in the video, or outside of it? Which one represents the true me, and where exactly I am?"

Brain

Scale, chains, needles / 42x35x31cm / 2016
Photo by Park Hongsoon

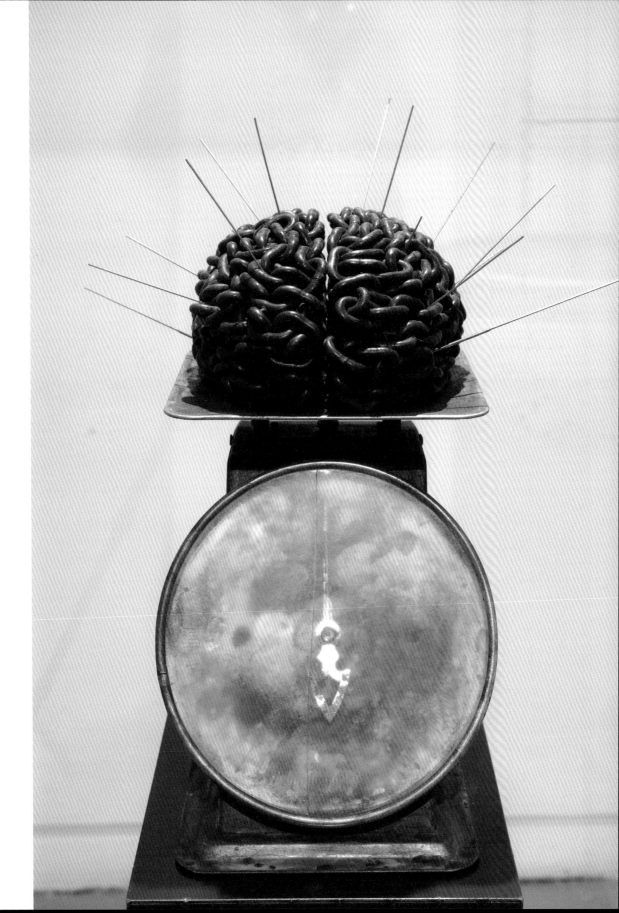

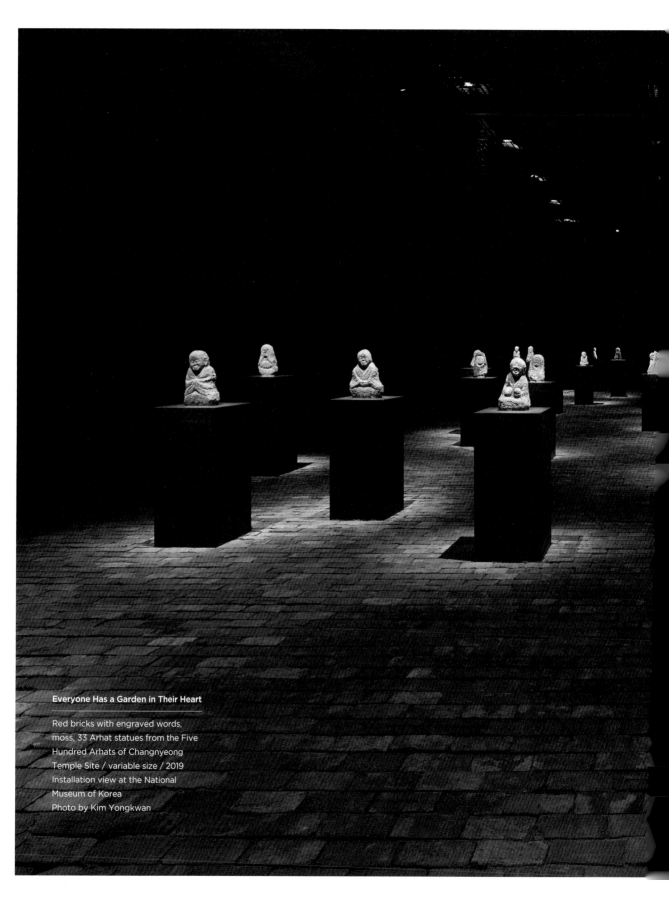

Everyone Has a Garden in Their Heart

Red bricks with engraved words,
moss, 33 Arhat statues from the Five
Hundred Arhats of Changnyeong
Temple Site / variable size / 2019
Installation view at the National
Museum of Korea
Photo by Kim Yongkwan

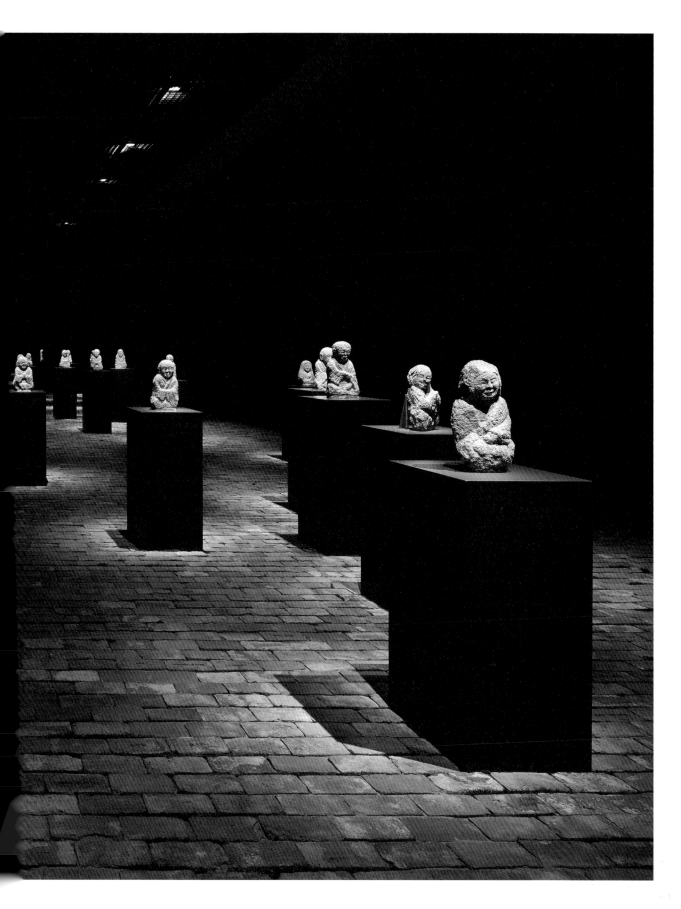

We now find ourselves in a narrow, winding alley. Moving through a shadowy passage, we reach a small room at the end, where a circular water tank sits, slowly filling with black water. This black water represents the unconscious. Viewers can gaze into the reflective surface of the water and confront their forgotten selves. The piece invites a self-reflective experience. The artist has placed a yellow cellophane over a small window. The view through the cellophane creates a sense of a sudden return to the past, as if the artist is summoning the past, or the self from a previous time, into the present. The artist also places the brain on an old measuring scale, using this as a way to question whether humans, represented by the brain, are fundamentally material (materialism), mental (idealism), or spiritual (spiritualism).

Kim Seungyoung draws from his own experiences to pose an existential question that resonates with everyone. The question, initially personal, is later expanded and transformed into works that explore relationships with others. Among his many pieces, the speaker tower stands out as one of the most iconic. This work features a stack of speakers arranged into a tower: It is likely the largest single sculptural piece in the artist's collection. When sound is embedded, the tower emits sound. This work can also

Two Chairs
Burnt chairs, ashes from burnt logs
and the belongings of Kim's late
mother /
97x182x730cm / 2024
Installation view at Kim Chong
Yung Museum
Photo by Kim Yongkwan

Tower of Babel

Speakers, 8-channel sound,
variable size, sound design
by Oh Yoonseok / 2023
Installation view at the National
Museum of World Writing Systems
Photo by Kim Yongkwan

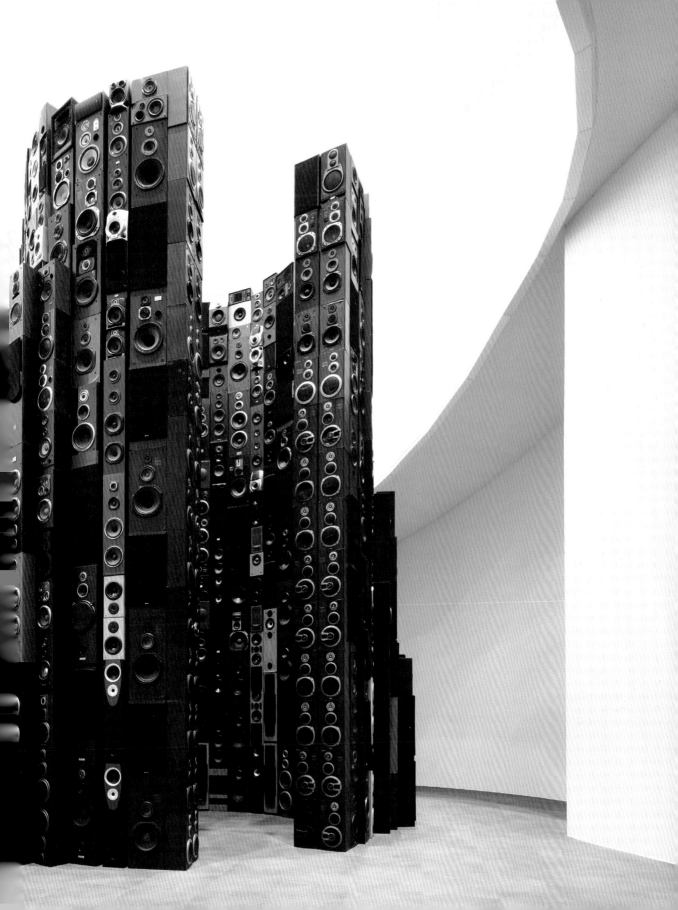

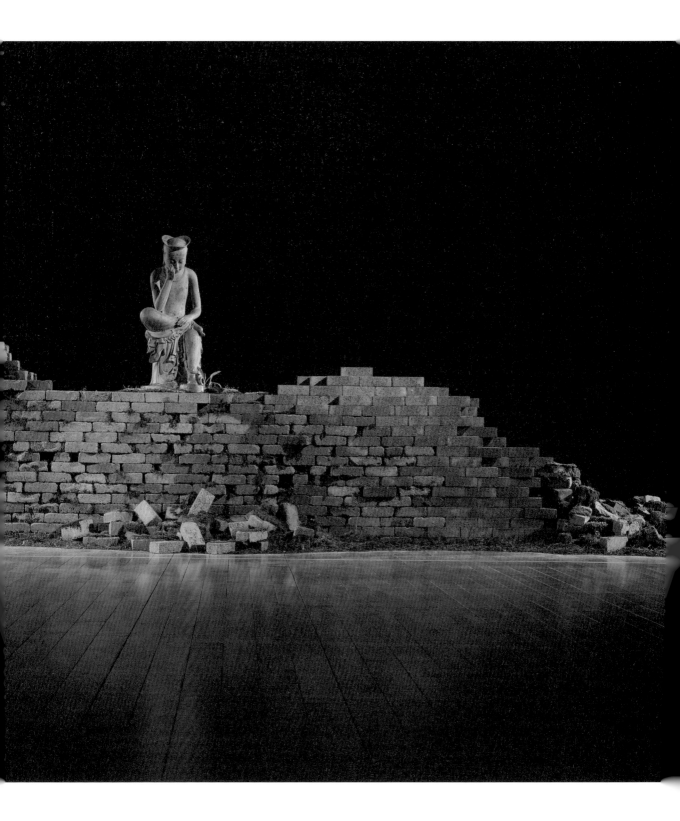

be viewed as a form of "acoustic sculpture," where sound itself is treated as an intangible sculpture. The piece changes depending on the type of sound it holds, altering its context and meaning. If it captures and plays the sounds of people passing by, it becomes akin to a public square sculpture. If the sounds of unintelligible words or disjointed conversations are played, it delivers a critical message on the alienation and lack of communication in modern society. Alternatively, if nature sounds, like birdsong, are incorporated, it offers a form of nature-based therapy, providing a meditative experience that connects one to their primal self.

This work opens up a space for healing and self-reflection, offering an opportunity to connect with one's inner self. It may have served as a turning point. As a contemporary artist, Kim Seungyoung was the first in Korea to collaborate with a museum for an exhibition. The museum, functioning as a repository of time, was revitalized through the intervention of contemporary art, awakening its dormant temporal layers. This event likely marked a shift in traditional exhibition practices.

Sadness
Cement casting, cement bricks, moss / Variable size / 2021
Photo by Kim Mingon

Sympathizing Sculpture

This exhibition focuses on five hundred Arhat figures unearthed from the Changnyeongsa Temple site. It debuted at Chuncheon Gallery in 2018, followed by a showcase at the National Museum of Korea in 2019. In 2021, celebrating the 60th anniversary of diplomatic ties between Korea and Australia, the exhibition traveled to the Powerhouse Museum in Sydney. The display featured a floor of cracked bricks, with the 500 Arhat figures elevated on pedestals above it. The cracked bricks are etched with messages of comfort and encouragement, such as "Thank you," alongside reflective questions like "Are you truly free from yourself?" These engravings evoke a sense of silent dialogue with the ancients. Visitors were encouraged to step inside the sound tower installed in one part of the space, inviting them to listen closely to the sounds emanating from their own inner world. In a 2023 exhibition at the National Museum of World Writing Systems in Songdo International City, the artist presented an installation inspired by the Tower of Babel — a symbol of humanity's first linguistic event — which garnered widespread acclaim.

Sadness (Detail Shot)

Cement casting, cement bricks, moss / Variable size / 2021

Through these museum collaborations, Kim Seungyoung extends beyond the realm of commonly recognized sculptures and structures, pushing the limits of the museum as a space. This approach reveals new possibilities for expansion, showcasing the fusion of boundary-defying and horizon-extending spatial installations and artistic creation. This piece can be regarded as a work of world-historical significance, encapsulating a vision of civilization. It resonates with a 2002 performance where a Japanese artist, embarking on a journey from Japan, met and interacted with Kim Seungyoung, who began his journey from Korea, at the maritime boundary of the Korea Strait.

Now, we encounter the Weeping Buddha, a subtle reinterpretation of the original Pensive Bodhisattva (National Treasure No. 83). In the original, the finger delicately touches the chin, while in this version, the finger has moved beneath the eye, as if wiping away tears.

The head is also slightly tilted forward. Is this adjustment meant to intensify the sense of sorrow? Indeed, the Buddha is weeping. Why is the Buddha shedding tears? The contemplative figure has transformed into a weeping one. At the culmination of thought lies crying, sorrow, and sympathy. Thoughts meander from one place to another,

ultimately arriving at the final destination: a sympathy for existence. In this way, thought and sympathy become one and the same.

A Buddhist monk is seen sweeping the yard — a task he performed yesterday, continues today, and will repeat tomorrow; endlessly sweeping. Even when there is nothing specific to clear away, he persists in sweeping the space. In doing so, the monk is also sweeping his own mind, worries, and inner self. This act could be viewed as a reflection of how the artist perceives the essence of art, and perhaps even as a self-portrait of the artist.

Kim Seungyoung's works embrace a wide range of subjects, from an elderly woman sitting in a winter market, trying to warm herself on a red electric metal chair with peeling paint, to a lifeless bird. Through these pieces, he investigates the concept of the true self (as understood in Buddhism), while also reflecting on the historical perspective and scale of civilization. His work is infused with depth, human warmth, and sympathy, as it contemplates the existential condition of humanity.🅚🅢

Photo by Park Hongsoon

An Artist Who Carves Profound Human Warmth : Kim Seungyoung

My relationship with society :
A fascination with vanishing objects.

Q. "Who am I?":

An existential question

My work can be seen as a personal journal, reflecting the connections I've had with people and the places I've experienced throughout my life. While viewers or critics may interpret my art in various ways, I welcome these perspectives, reimagining them and sometimes incorporating them into my creations. For me, making art is an exploration of relationships — with individuals, society, and the objects around us. I see my work more as a question than a message. I've transformed question marks into art, and through my interaction with materials, I aim for the artwork to ask a question of the viewers, encouraging them to reflect on themselves. It is with this thought that I approach my work.

Q. What is sculpture that contains sound?

I often collaborate with other professionals. For instance, in video projects, even though I'm not familiar with the technical details of video production, I focus on expressing my ideas, and experts help bring them to life. In a sense, I take on the role of a director. The same approach applies to sound work. I don't personally

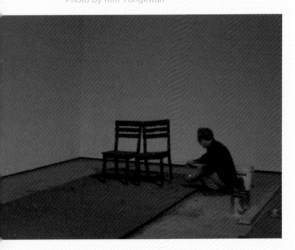

Sweep

Desk made of iron, chair, paper, pen, trash can / 2021
Participatory installation artwork
Installation view at Seongbuk Museum of Art
Photo by Kim Yongkwan

manipulate anything, but I engage in extensive discussions with experts to convey the intentions behind what I want to achieve. While people typically judge things visually first, the auditory experience connects with them in a completely different way.

Q. Where do you plan to realize your next site-specific installation artwork?

"Memory" is a video artwork created with names. Typically, at the end of a film, the "closing credits" roll, but in this piece, the names of people I've encountered continuously scroll. Among them are those I admire, those I don't, and even some whose relationships have left me with regret or disappointment. Nonetheless, I believe each of these individuals has played a role in shaping my identity. What began as a 3-minute video has now expanded to over 15 minutes. In 2025, I plan to bring together

about twelve of these individuals for a fashion show. Rather than being defined by their names, I will capture their essence through their intersecting moments on the fashion runway, blending video work with installation art.

Who is Kim Seungyoung?

Born in 1963, he earned a Bachelor of Arts in Sculpture from Hongik University. His work was featured at the Gwangju Biennale in both 2002 and 2004, and he participated in the Anyang Public Art Project in 2006 and the Gangneung International Biennale in 2008. Additionally, he has been actively involved in various nomadic art residency programs across diverse and remote locations. Kim Seungyoung earned acclaim for marking a new milestone in museum exhibitions with shows like The Face Resembling Your Heart (Chuncheon Gallery, 2018) and *The Arhat Resembling Your Heart* (National Museum of Korea, 2019). He also showcased *Five Hundred Arhats of Changnyeong Temple Site* at the Powerhouse Museum in Sydney (2021), celebrating the 60th anniversary of Korea-Australia diplomatic relations. Additionally, he presented *The Great Journey of Letters and Civilization* as the opening exhibition at the National Museum of World Writing Systems in 2023, where he featured the Tower of Babel installation. Kim Seungyoung has been honored with many prestigious awards, including the Grand Prize at the Dong-A Art Exhibition (1998) and the Jeon Hyuk Lim Art Prize (2020). Additionally, he received the Kim Chong Yung Sculpture Award.

Please scan the QR code to watch the sculptor's interview video.

COLLISION

Humans in Relationship with Animals, Nature, and the Environment
Geum Joonggi

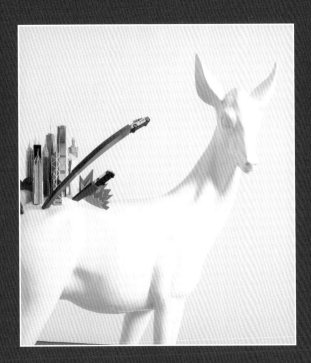

Geum Joonggi's work explores the uneasy coexistence between humans and nature. His art reminds us of the reality that humans are part of an earthly community required to coexist harmoniously with nature. He actively demonstrates how art can play a vital role in promoting environmental sustainability for a more enduring future.

Kang Jaehyun / Curator at Savina Museum of Contemporary Art

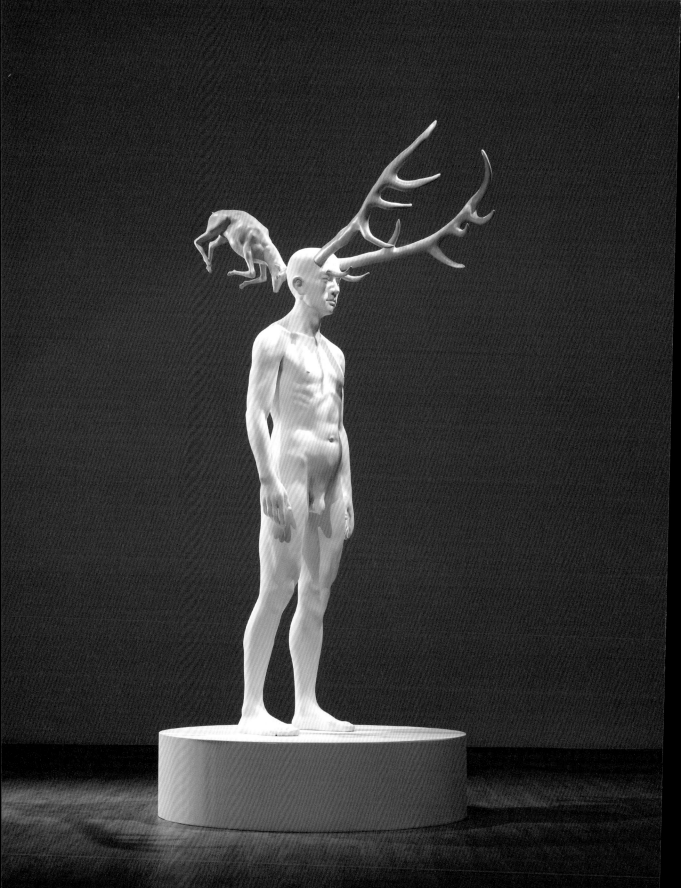

Geum Joonggi's art showcases a range of animals we recognize, yet he reimagines them in ways that transcend their natural forms. Without resorting to distortion or exaggeration, his depictions are not strictly realistic either. Using vivid, glossy, and vibrant colors, his works exude a modern aesthetic with smooth, polished shapes that captivate the eye. These visuals carry a dual message: a critique of the ecological crisis and a reflection on the relationship between humans and the living beings with whom we share the planet.

For more than two decades, animals have been central to Geum Joonggi's artistic expression. His animal series reflects a distinctive worldview, engaging with the social and environmental issues of the era. The roots of his perspective were established in the 1990s, when his focus on the existential value of everydayness and seemingly insignificant objects began to evolve. Over time, his work shifted away from an anthropocentric viewpoint, embracing a more expansive concern for the global environment.

Geum Joonggi's early works included three-dimensional installations crafted from materials like candles, soap, dust, gas masks, and recycled items. In his 1999 solo exhibition, *Elicitation & Revelation*, he delved into the realms of

Sensory exposure
57x116x185cm /
Urethane painting on F.R.P / 2011

existence and non-existence from both microscopic and macroscopic perspectives. This exhibition focused on the interplay between humanity and the environment. One notable installation enabled viewers to examine dust collected from his atelier, magnified a million times under a microscope, resembling an exploration of the cellular world. Geum Joonggi sought to explore the unseen world of microscopic particles, the passage of time they carried before settling on the surface, and the unknown realms within that journey of time. His exploration didn't stop there. He magnified the dust particles observed under the microscope, transforming them into striking three-dimensional sculptures over three meters tall.

By enlarging tiny, invisible specks into grotesque and unfamiliar forms, Geum Joonggi sought to "elicit and reveal" the energy and hidden phenomena contained within these overlooked entities. Motivated by questions surrounding these dirty and ambiguous presences that we instinctively wish to erase, he aimed to uncover the fundamental essence of things.

Optimistic form

70x80x20cm /
Urethane painting on F.R.P / 2011

Sensory exposure

150x90x92cm / Nickel plating on
bronze, stainless steel / 2012

The Paradox of Loose Collisions

Geum Joonggi began creating works that highlight the value of existence in things that transform or fade with time, the vanishing condition of living organisms, and the need for ecological awareness in the face of environmental pollution crises. In 2000, Geum Joonggi presented an installation featuring plastic waste bound to a large, decaying tree with a net, symbolizing a contemplation of death while accentuating the urgency of environmental protection. His focus on environmental issues began to shift toward concerns for animals during a year-long stay in Paris, France, in 2002.

Among the many museums and galleries in Paris, Geum Joonggi was particularly struck by the Natural History Museum. The vast array and scale of the mammals on the first floor left a powerful impression on him. The organized classification of animal species and the research materials were nothing short of awe-inspiring. The Natural History Museum was a major source of inspiration for Geum Joonggi, to such a degree that he visited it multiple times, spending entire days there from morning to evening. Captivated by the appearances and diverse patterns of the animals, his curiosity about them deepened. It was during this time that he first became aware of the existence of non-human creatures, which led him to start creating works centered around them.

Loose collision

110x45x147cm /
Urethane painting on F.R.P / 2012

During his time in Paris, the workshop where Geum Joonggi was staying wasn't suitable for sculptural work. Unlike in Korea, he struggled to find the proper materials, and the space itself was not ideal. However, he was fortunate to have brought his Nikon FM2 camera, which became the perfect tool for continuing his artistic practice in this unfamiliar setting. Around the same period, significant photography exhibitions were being held throughout Europe. When Geum Joonggi decided to focus on photography, he enrolled in a short-term photography program at the École des Beaux-Arts de Versailles. Despite having already held over five solo exhibitions and participated in numerous group shows, he went back to being a student. This period allowed him to revisit the fundamentals and re-align with his original artistic goals, exploring how to bridge the gap between three-dimensional and two-dimensional space, as well as the relationship between objects. He set up a small darkroom and began developing his own photographs.

Geum Joonggi's photographic works include a wide range of objects, such as toys, globes, and dolls. Creating a single piece requires him to go through numerous sketches and simulations. Instead of merely documenting the objects, his goal is to express the sense of spatial volume and the tension between them. When choosing objects,

Threat culture

123x60x56cm /
Candy coating on bronze / 2010

he carefully considers their relationships, the size and distance between them, the lighting, and the background color. Once these elements are established, he incorporates or juxtaposes the objects to create scenes that resemble a theatrical production. The result of this process is the *Loose Collision* series. The pairing of the contradictory and paradoxical words mirrors the artist's method of arranging objects. The term "loose" softens the destructive connotation of "collision," helping to alleviate the tension and form an otherworldly space where both words can coexist.

The photographic piece *Loose Collision* (2005) shows a dark skull placed beside a jointed doll with a visible surgical scar on its head. The photograph was taken against a red background. The grotesque yet humorous portrayal of life and death in a single image evokes the feel of a scene from a cult film. Through many works created in this style, the artist encourages viewers to use their imagination, leaving space for personal interpretation of the scenarios depicted in the photographs.

Coexistence with nature, witty reflection

The *Sensory exposure* (2011) series explores the clash and connection between humans and animals. One of the works in the series features large deer antlers deeply embedded into a human's head. While the pose suggests the deer has attacked, it could also be seen as the human having taken the antlers from the deer. Animal antlers are significant as both defensive and offensive tools. The antlers serve as a means of reproduction and courtship, and they also symbolize power and strength. The human standing confidently with the deer antlers on their head embodies this power, while the deer, tragically falling face-first and embedding its antlers into the human's head, represents the grim fate of a life violently taken by humanity.

Sensory exposure appears to be veiled in a transparent cloak, perfectly mirroring its surroundings. A young lion stands unsteadily on a broken, cracked pedestal. The mirror-like surface warps and reflects the viewer's image, providing a variety of visual experiences. At the same time, the reflection acts as a warning from nature, reminding humanity of their potential to face the consequences of their own actions. On the other hand, the vivid colors of the climbing frog in *Forest* (2008) are gorgeous and surreal. The colors are inspired by the poison dart frogs

found in the rainforests of Latin America. The frog's name comes from its highly toxic skin, which Indigenous people historically used to coat their arrows. Despite its dangerous toxicity, the frog's small size and vibrant colors have made it popular in the companion animals' market, leading to its classification as an endangered species.

Geum Joonggi's works are primarily crafted through the casting process. Initially, the skeletal structure of the animal is sculpted in clay, incorporating its anatomical features. The flesh is then added and simplified to the greatest extent possible before the surface is smoothed. The final piece is cast in metals like bronze or aluminum. The surface is painted using a urethane coating, a technique commonly used for automobiles and manufactured products. The artist chose this painting technique to metaphorically represent animals as tools for human use, portraying them as commercial goods. As a result, the works, completed in various colors, possess an artificial yet visually appealing quality. This approach not only makes the pieces more relatable as familiar imagery for viewers but also carries symbolic meaning, thus conveying the artist's message. Geum Joonggi employed this technique to craft numerous three-dimensional animal sculptures, including gorillas, deer, lions, pigs, rabbits, giraffes, turtles, frogs, and lizards. Through their diverse poses and

expressions, he sought to illustrate the uneasy coexistence between humans and animals.

Disasters like heatwaves, heavy rains, droughts, and typhoons are intensifying worldwide, signaling the pressing crises that threaten our lives. Geum Joonggi addresses these impending dangers through his distinctive, sensorial, and witty works, highlighting the urgency of the challenges humanity confronts. For over three decades, the artist has consistently reflected on the connections between humans and objects, humans and the environment, and humans and animals. He remains a strong advocate for human efforts to achieve harmony with nature. His art reminds us of the reality that humans are part of an earthly community required to coexist harmoniously with nature. He actively demonstrates how art can play a vital role in promoting environmental sustainability for a more enduring future.Ⓚⓢ

A Sculptor with a Deep Affection for Animals : Geum Joonggi

Portraying ecosystems, animals, climate, and the crisis of extinction in a captivating and contemporary manner.

Q. What message do you want to convey through your work on animals?

Originally, my work didn't focus on animals as a subject. During my graduate studies, I concentrated mostly on installation art, working with metaphorical themes and temporality using materials like paraffin. After graduating, I held a solo exhibition and shifted towards environmental topics with a project titled *The Web of Life*.

This marked the beginning of exploring more intricate concepts, incorporating photography and casting, which ultimately led to my animal-themed series. I selected the theme of "loose collisions" for my work, opening up avenues to explore subjects like human conflicts and the clash of civilizations. One of my pieces, a large rabbit sculpture, is located in Pocheon. My goal is to integrate animals, objects, and human forms, not merely to highlight

the humor and playfulness that define humanity, but to imagine and craft scenes where these elements seamlessly blend and interact within the artwork.

Q. Can you tell us more about "loose collision"?

The *loose collision* series was an extensive body of work that involved a great deal of time spent on arranging the photographs, adjusting the lighting, and perfecting the composition. I carefully considered how to portray the relationship between the frog and the bottle, how these elements interact within the frame, and how they create a sense of collision, prompting the viewer to imagine various narratives. Rather than conveying a single message, the *loose collision* series invites viewers to form their own interpretations and ideas.

Q. Is there an art piece you feel wistful about?

One piece that comes to mind is a 3-meter rabbit I created for an exhibition at Seoul Museum of Art, titled *They Have Returned*. The process of making it was incredibly challenging due to its immense size. However, after the exhibition ended, I realized there was no place to store the piece. It was so large that it couldn't be kept anywhere. I felt deeply saddened by this situation. I'm not sure where it is now, but I once spotted it in a garden where I had been invited. Seeing it again brought me joy. Even now, whenever I think about that work, my heart aches.

I'm still exploring themes related to animals, though I'm not sure how they will evolve in the future. I believe my work will continue to reflect concepts like temporality, existence, and the relationship between animals and objects. My latest piece, *Everyone's Existence*, just opened yesterday after the installation was completed. It deals with the theme of temporality and the narrative of space-time, blending the concept of time. I hope it will convey ideas about human thought and the decision to act on those thoughts. As I continue developing the work, I'm reflecting on how the visualization of time, space, and existence can connect and influence each other, potentially shifting our perspectives.

Who is Geum Joonggi?

Born in 1964 in Sangju, Gyeongbuk, he obtained a Master's degree in Sculpture from Hongik University. His career gained momentum in 1995 when he received the Excellence Award at the Joongang Biennale, followed by his first solo exhibition in Seoul the next year. In 2000, he participated in the themed exhibition *The Net of Life* at the Sungkok Art Museum, marking the beginning of his involvement in exhibitions centered on environmental issues. He further expanded his artistic practice through participation in various artist residency programs, including the Cité Internationale des Arts in Paris (2002), the Changdong Residency (2003) run by the National Museum of Modern and Contemporary Art, and the Gana Atelier (2004).

His remarkable solo exhibitions include *Loose Collision* (2005), *Threat Culture* (2008), and *Optimistic Form* (2011). Among his group exhibitions are the 5th Gwangju Biennale themed exhibition *A Speck of Dust, a Drop of Water* (2004), *Light and Environment* (2006, China), the *Opening Exhibition of the Nam June Paik Art Center* (2008), *Korean Contemporary Sculpture 2010, The Dream of a Butterfly* (2011), and *Hangul Awakens Synesthesia* (2021). He has also participated in several art fairs both domestically and internationally, and his works are included in the collections of various institutions, including the National Museum of Modern and Contemporary Art, Seoul Museum of Art, Gyeonggi Museum of Modern Art, Jeju Museum of Contemporary Art, Pohang Museum of Steel Art, and Savina Museum of Contemporary Art. Currently, he serves as a professor in the Department of Fine Arts at Andong National University.

Please scan the QR code to watch the sculptor's interview video.

NATURE

New Sculptural Expression
Found in the Essence of Form :
Lee Jaehyo

Lee Jaehyo seeks to grasp the essence of things by delving into their core

rather than focusing on their external appearance. Whether it be working with nature,

the universe, or a piece of wood, he prefers to convey form itself

without relying on representational depiction.

Lee Kyungmo / Art critic

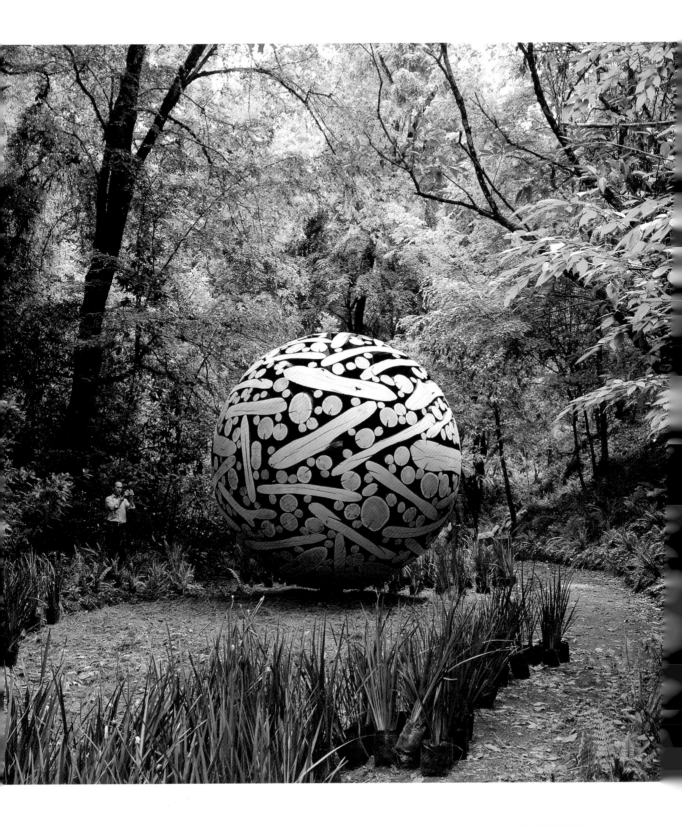

Lee Jaehyo sculpts and refines abandoned artificial objects or overlooked natural materials, merging them into solid forms that exude a powerful vitality. These creations can be viewed as sculptures or installations or become part of their environment, subtly reflecting nature's cyclical structure. Lee Jaehyo's work, emphasizing spatial structure and placeness, reflects a labor-intensive process. Yet, he asserts, "My work and I are separate entities." This paradoxical statement encapsulates the essence of his art. "My work is the outcome of a process of self-exploration. However, I do not intend to incorporate my personal narrative into it. Simply admiring the inherent beauty of the wood is sufficient. When the artwork stands independently, it will naturally connect with everyone." (Excerpt from Lee Jaehyo's Artist Statement)

In his essay *The Death of the Author*, Roland Barthes challenges the view of the author as the source of a text and its meaning, as well as the subject of interpretation. His assertion of the "death of the author" signals the end of the artist's role as a creator. In this perspective, the author is no longer regarded as a creative genius or the ultimate source of meaning but instead becomes a mere consumable product between the text and its interpretation.

Lee Jaehyo's art aligns with this perspective. Rather than embedding a singular truth in his works, he acknowledges

0121-1110=115075

Wood (Chestnut) /
560x130x380cm / 2015

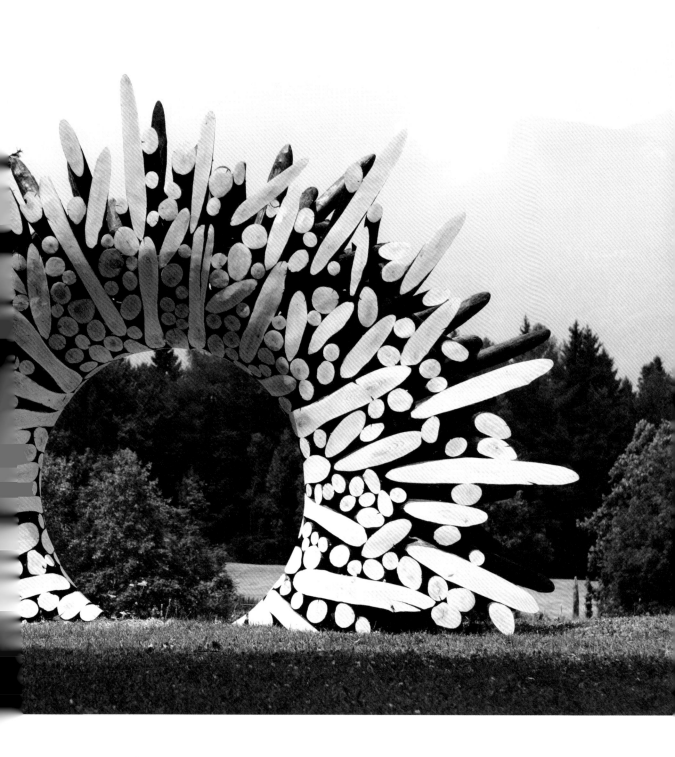

that each person perceives truth differently. As we exist within our own cognitive frameworks and personal worlds, we do not impose our interpretations, perceptions, or experiences as absolute truths onto others. In the end, artists are destined to develop their own perspectives, experiences, and understandings through their distinct practices and modes of expression.

An Alchemist Who Breathes New Life into Nature

Lee Jaehyo approaches his work with the dedication of a spiritual seeker, guided by his unique perspective and method. However, on a larger scale, his art is not focused on producing a finished product in the traditional sense, but rather on the journey of arriving at a result through personal, individualized processes. It is not difficult to seek communication by expressing the value of nature, but the effort to embody the relationship between perceptions in a single object and breathe life into it is more comparable to a spiritual pursuit than to art. Like a seeker, he wanders in search of nature's essence, focusing solely on gathering fleeting discoveries and revitalizing them.

Lee Jaehyo's artistic approach, which combines the exploration of natural life and vitality with sculptural experimentation, invites a range of reflections from the viewer. He describes his artistic process as "identifying

0121-1110=118071

Stone / 400x400x400cm / 2018

the unique qualities of materials to discover the form that best suits them." In this sense, the artist parallels an alchemist, seeking out natural materials that have reached the end of their lifecycle or discarded artificial objects, recognizing their sculptural potential, and transforming them into something of new value. Lee Jaehyo's work does not engage with the external value objects may convey. Interpreting it within a narrative context driven by specific meanings is futile. Unlike traditional sculpture that often reproduces ideal forms through logical structures, he emphasizes the material presence of the matter itself and the psychological responses it evokes. In this way, his work powerfully affirms that it is not a representational object, but an epistemological entity existing at the intersection of the material and immaterial.

Presentation of New Form, Not Representation

Lee Jaehyo adopts a free-spirited approach to the traditional sculptural task of "original form and representation," alleviated from the constraints of thematic storytelling while instead focusing on the pursuit of "vitality," resembling a relentless journey of self-discipline. The monumental transformation of discovered objects and their inherent qualities shifts focus. This process serves to mask the artist's longing for art that resists even the

0121-1110=113018

Wood (Chestnut) /
220x220x1500cm / 2013

New Sculptural Expression Found in the Essence of Form : Lee Jaehyo

0121-1110=124041

Wood (Needle fir) /
400x133x344cm / 2024

New Sculptural Expression Found in the Essence of Form : Lee Jaehyo

slightest trace of futility. This is the artist's clear intention.

Lee Jaehyo's work, which may seem rigid and meticulously structured, is not a space for personal self-justification; instead, it becomes a realm of eternal return, where the concept is entrusted to time and the body yields to space.

It is likely that Lee Jaehyo's aesthetic pursuit is immersed in achieving the ideal sculptural form, yet his deeper focus lies in the uniqueness and intrinsic essence of nature. By exposing the raw cross-sections of wood and revealing the visible growth rings, he showcases the history of a tree that has come to the end of its life. Simultaneously, by collecting branches and leaves and reorganizing them, he seeks to illustrate the natural structure of the life cycle.

Although his work involves a labor-intensive, time-consuming process and a strong sculptural focus on achieving aesthetic perfection, the artist steps back and prioritizes nature. In doing so, he invites us to engage in a distant aesthetic experience.

Nevertheless, we can discern strong sculptural qualities in the polished surface of the finely crafted wooden cross-sections, the optical elements, the nail work that subtly reveals the negative aspects of metal in contrast to the positive features of the charred, dark support fixture, and the geometric patterns that intermittently emerge throughout the piece. Other artistic qualities emerge through the installations, which engage with space and

counteract gravity by hanging in an orderly arrangement. They aim to convey the energy of the universe through natural fragments, as well as through objects that support one another and radiate an aura across different areas of space with a solid structure.

Lee Jaehyo seeks to grasp the essence of things by delving into their core rather than focusing on their external appearance. Whether it be working with nature, the universe, or a piece of wood, he prefers to convey form itself without relying on representational depiction.

Lee Jaehyo expresses a humble approach by emphasizing sustainability through the traces of his actions instead of through representational works, or by revealing the raw essence of materials to connect with the inherent vitality of the medium. Furthermore, the symbolized natural objects that remain within the space aim to radiate powerful sculptural forms, underscoring the artist's meticulous craftsmanship. While leaves and stems are arranged into clusters, they also differ in shape, color, and lightness/darkness, promoting both unity and contrast. Through this, Lee Jaehyo's goal is not to distinguish the appearance of natural objects but to reveal a deliberate intention to explore new sculptural qualities. This is achieved by varying forms, experimenting with materials, and developing an evolutionary process that reflects creation and disappearance.🅴

Concentrated Life Energy : Lee Jaehyo

A sculptor crafting wooden spheres exhibits works daily at a gallery in Yangpyeong.

Q. How do you find materials for your sculptures?

It's all about staying sensitive to my surroundings. When it rains, I let myself get wet; when stars appear at night, I just gaze at them. I try to preserve that emotional state. I try to keep my mind clear and use whatever catches my eye at the moment. I don't plan ahead, thinking, "I must create this or that." I liken my creative process to a "treasure hunt game." I have specific forms that I previously envisioned in mind. When I see a tree, I recognize that its thick branches can create certain shapes, while the smaller branches can be collected to form other designs. Trees naturally offer shapes that inspire specific forms. I follow these inherent features spontaneously. For instance, pieces made from intertwined small branches are created by stacking them, akin to a brush. Conversely, thicker branches are collected to form larger

items, like tables. I favor using wood that is naturally twisted, seemingly unusable, or easily available. Modeling involves adding material, whereas carving removes it. Most of my work utilizes the additive process. This approach applies to both my nail and woodwork. By continuously combining pieces to build mass, it can be classified as modeling.

Q. What does it mean to create a work of art for you?

Using natural materials imbues my art with an innate energy. If I can highlight that essence while removing personal stories, the work becomes universally comprehensible —transcending the need for translation. Regardless of nationality, age group, or era, I am most interested in eliciting emotions that are shared equally. I strive to uncover the emotions that all humans share.

Q. In what ways can we appreciate sculpture?

When you view a piece, perhaps with a slight smile and an open heart, take your time, and it will begin to feel familiar. The longer you observe, the more it resonates with you. There's no need to consciously remember it. What matters is the experience of seeing the work in the moment, not the effort of remembering it. Just like listening to music, you gaze at the sculpture, sensing what it makes you feel. Even if you can't put it into words, the feeling itself is what appreciation is all about. Everyone is meant to interpret it in their own way. That's why I deliberately left my works untitled. The belief that art must always convey a fixed meaning or message stems from a misguided approach to art education. When you witness a breathtaking mountain landscape, you don't need an explanation to admire it. When you pass by a beautiful tree on the street, it simply brings you joy. The same principle applies to sculpture.

Q. How has opening your Yangpyeong studio and gallery changed your life?

I've held over 50 solo exhibitions. Normally, having 20 solo shows is considered a lot for an artist, but I've done significantly more, and each one required a tremendous amount of energy. Now, in Yangpyeong, I'm holding a solo exhibition 365 days a year, eliminating the need to showcase my work elsewhere. I grew convinced, perhaps a bit stubbornly, that if people want to see my work, they should visit my gallery. Consequently, my team has

become smaller, and the volume of work I produce has reduced. However, not hosting external exhibitions doesn't mean I've stopped creating. I continue to engage in my art daily while keeping the gallery open.

Q. What are your upcoming projects?

Lately, I've been planning pieces that incorporate stones and nails. Previously, most of my work was non-representational and abstract, but now I'm creating a horse sculpture using stone. I chose a horse because, among all the animals I know, its musculature and form are the most beautiful. The technique of suspending stones has slightly evolved in this project, but there's no specific meaning behind it. Why did I choose a horse? Simply because it's beautiful. In the future, I might create a cat or something else. Among the visitors to my Yangpyeong gallery, the most rewarding feedback

came from two different people who said the same thing: "It feels like I paid to come here and got a hammer-like hit in the head." That's precisely the impact I aim for with my work.

Please scan the QR code to watch the sculptor's interview video.

Who is Lee Jaehyo?

He majored in Sculpture at the College of Fine Arts, Hongik University, and has earned a variety of prestigious awards, including the Grand Prize at the "Hankook Ilbo Young Artist Invitational Exhibition" (1997), the "Today's Young Artist Award" from the Ministry of Culture and Tourism (1998), the Sculpture Prize at the "Osaka Triennale" (1998), the Kim Sechoong Young Sculptor Award (2000), the Woodland Sculpture Prize (2002), and the Excellence Award at the "Beijing Olympics Environmental Sculpture Exhibition" (2008).

Since his debut solo exhibition at the Seoul Arts Center in 1996, he has held more than 50 solo exhibitions at renowned venues, including the Ilmin Museum of Art, Cynthia-Reeves Contemporary in New York, Albemarle Gallery in London, among others. His works are part of prestigious collections both in Korea and internationally, including the National Museum of Modern and Contemporary Art, Ilmin Museum of Art, Osaka Contemporary Art Center in Japan, Grand Walkerhill Hotel Seoul, Grand Hyatt Hotel in Taiwan, Park Hyatt Hotel in Washington D.C., Industrial Bank of Taiwan, Nike Sport Research Lab, Signiel Seoul Lotte, and Apple Korea, among others.

IMAGINATION

Parodies, Hybridity, and Variations in Sculpture Language :
Sung Donghun

Sung Donghun's work embodies a powerful sculptured art rooted in perseverance and
the spirit of experimentation, pushing the boundaries of imagination through the fusion
of diverse materials and objects. Moreover, his art comes to life through movement, wind,
sound, and the passage of time. His art reflects his own nature — a free-spirited individual
who embraces an unrestrained lifestyle and constantly seeks
new artistic challenges through exploration.

Kim Sungho / Art critic, Visiting Professor at Sungshin Women's University

It is often said that an artist's work reflects their personality. Sung Donghun's creations embody his reluctance to be confined by traditional norms and institutional rules, as well as his joyful and carefree approach to exploring new artistic experiments through unrestrained wandering.
A prime example of this can be seen in his *Don Quixote* series. This series rose to prominence with his work *Don Quixote II Korea* (1990), which earned the grand prize at the inaugural MBC Korean Figurative Sculpture Exhibition. The piece is a parody of Don Quixote, the iconic protagonist from Miguel de Cervantes's novel.

Sung Donghun's *Don Quixote* series highlights the absurdity of the novel's protagonist while also pushing beyond these traits through imaginative variations.
In *Cow of Illiteracy-Don Quixote* (1996), Don Quixote is depicted wielding a long lance, integrated with mechanical components and iron elements. At the same time, his steed, "the aging Rocinante," is reimagined as a reckless, cement-formed bull. In a 2009 piece, Rocinante is depicted as a bull encircled by flowers, while in a 2014 work, he takes the form of a plump hen.

The *Don Quixote* series showcases imaginative fusion of hybridity and variations that surpasses expectations. The artist not only portrays Don Quixote as an unsteady figure

atop a faltering horse but also reimagines him as a bold, upright rider astride a charging bull, his feet lifted mid-air. Utilizing construction and industrial materials like cement, rebar, and steel, the transformed images of Rocinante as different animals and Don Quixote's exaggerated poses are as satirical and intriguing as the novel's original themes.

Just as Cervantes's portrayal of the "delusional Don Quixote" serves as a satirical self-portrait, drawing from his own experiences as a former prisoner of pirates and a wounded soldier, Sung Donghun's "Don Quixote" emerges as a reflection of himself — an artist navigating a harsh modern world where art is sometimes dismissed as mere waste.

The parodies, hybridity, and variations in Sung Donghun's Don Quixote series are direct and instinctive; reminiscent of the raw, earthy humor of ordinary people. Yet, they also carry an aesthetic sense of critical wit, similar to black humor. In other words, through "a new parody of a parody," he caricatures familiar "old elements" while sharply satirizing the "contemporary era," aiming to convey a message that strikes a chord with the public. Rooted in instinctive satire derived from self-portraiture, his *Don Quixote* series can be seen as a presentation of a "narrative of escape" for modern individuals, who endure

The Rhinoceros of the Fake Kingdom

Iron, Ceramic, Aircraft Materials / 205x170x360(H)cm / 2015

Cow of Illiteracy-Don Quixote

Iron, Bronze, Cement /
1000x400x800(H)cm / Outdoor
Sculpture, Cheonan City, Korea /
1996

Parodies, Hybridity, and Variations in Sculpture Language : Sung Donghun

a harsh and desolate reality, urging them to dream beyond the limitations of their current world.

Cheerful Imagination of Hybridity and Variations

The content-driven aspects of hybridity and variations in Sung Donghun's work — such as the interplay between tradition and modernity, the West and the East, art and technology, art and non-art, as well as the connection between the artwork and the audience — arise from the rich imagination that the artist infuses into materials and objects. His work, *The Rhinoceros of the Fake Kingdom* (2015), can be seen as a variation of *Don Quixote*, featuring a figure riding a rhinoceros. Through his imaginative approach that fosters the interaction between materials and objects, the piece vividly portrays a world of hybridity and variations.

This work, which merges diverse objects and materials such as steel, ceramics, and aircraft parts, is alive with energy, driven by the artist's imagination and the aesthetic meanings embedded in each material. True to its title, it constructs a "fake kingdom" where concepts such as living and non-living, past and present, Western and non-Western, technology and art, reality and fable, and the real and the fictional paradoxically intertwine. This piece

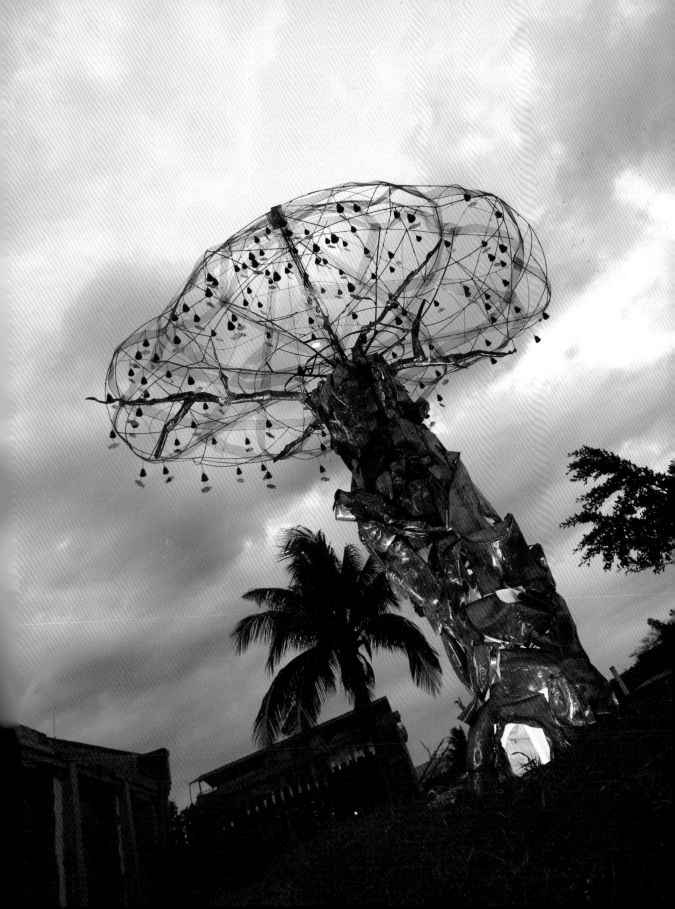

serves not only as a self-portrait shaped by the artist's imagination but also as a reflection of his interpretation of the modern human condition.

Many of Sung Donghun's works engage in sculptural experimentation, inviting the viewer to experience materials and objects through the lens of alchemical imagination. The piece *An Marjoo god's bodyguard* (2014), made from sludge — the byproduct left over from steel production in a furnace — depicts a figure riding a massive bird on a wide pedestal, subtly alluding to a variation of Don Quixote. The work is remarkable for its artistic experiment, using discarded sludge as a medium and transforming its form through the artist's imaginative vision. The work *Living Here and Now* (2013), featuring a figure standing upright with a long spear resting on the ground, *Movement of the Rails* (2014), a giant bull figure created from iron parts and sludge, and *Head* (2015), a horse's head sculpted from a mix of iron objects and ceramics, can all be seen as outcomes of the artists "alchemical material experiments," where "discovered objects" and "constructed objects" are seamlessly merged through the materials themselves.

The work *Meditation* (2015), in which miniature sculptures of a Buddha, horse, and bull purchased in India are cast to

form a large golden bull, cleverly employs the technique of "dépaysement — where familiar objects are placed in unfamiliar contexts, often seen in surrealist art or literature. In this piece, objects from different origins and the fragmented stories they connotate are brought together to craft a new, unified narrative.

The work *Itinerary of Time* (2017), which combines "discovered objects" like trumpets and toy cars with "constructed objects" such as bulls or elephants made from old wood, forms a surreal landscape infused with imagination by blending spatiotemporal elements of a fragmented past into a fresh context. Particularly noteworthy in his art is the use of materials like "ceramics" — typically made for practical use — and "beads," originally intended for decoration, as components of pure artistic sculpture. The work *The White Kingdom* (2015), featuring a vividly colored Chinese blue-and-white porcelain teacup placed on a deer's body, and *Blue* (2015), where the entire deer is adorned with blue beads, appear to merge elements of both the past and future within the present. In the *Blue* series, the incorporation of LED lights expands the sculptural language — traditionally centered on volume and mass — into a more mystical atmosphere, inviting the viewer on an imaginative journey through time and space.

Sculptural Experiments Encompassing Movement, Wind, Sound, and Time

Sung Donghun's work builds upon the language of traditional sculpture while pushing its boundaries by integrating movement and time. His piece *Into Brain* (2009) presents a massive head sculpture large enough for a person to enter, which continuously opens and closes through a hydraulic mechanism. As the head-shaped structure splits in half, opening from left to right, a pumpkin-shaped sculpture inside rotates. Pieces such as *Well-mannered Pumpkin* (2008) also incorporate this dynamic movement. These works fall under the category of kinetic sculptures, often described as "moving art." Engaging with these pieces, which continuously alternate between concealment and revelation, naturally draws the audience in, sparking curiosity and immersion.

Movement in his works is not solely driven by mechanical devices but also by natural forces like the wind. In *Sound Tree* (2010), for example, a towering stainless steel tree is decorated with countless small ceramic bells that sway with the breeze, producing beautiful and melodious sounds for the audience. This series, reinterpreted through multifarious materials and forms and installed in different locations worldwide, brings the "invisible wind" to life by causing the bells to sway. In doing so, it embodies a "moving

entity" while simultaneously evolving into a sculpture that captures the essence of "unseen sound."

Rather than adhering to traditional sculptural forms that emphasize volume and mass, Sung Donghun explores imaginative sculptural experiments by bringing together materials and diverse objects from various historical and cultural backgrounds. As a result, his work seamlessly integrates movement (kinetic sculpture), sound (sound art), light (light art), and time (nomadic art). Sung Donghun's work embodies a powerful sculpture rooted in perseverance, and the spirit of experimentation, pushing the boundaries of imagination through the fusion of diverse materials and objects. His sculpture comes to life through movement, wind, sound, and the passage of time.🅺🆂

A "Don Quixote" Sculptor : Sung Donghun

From Don Quixote to Sound Tree: Imagination Woven into Hybridity and Variations.

Q. Do you think that "A work of art resembles its creator"?

A work of art reflects its creator." I see this as a compliment to any artist, as it signifies a clear artistic identity and a distinct personal language. For sculptors, their language is expressed through their art. This implies that throughout my career, I have consistently stayed true to my artistic expression. In today's society, Don Quixote has become a widely recognized symbol. People are often categorized as having either a "Don Quixote-type" or "Hamlet-type" personality. A Don Quixote-like individual is typically perceived as bold, idealistic, and constantly immersed in grand fantasies. I have chosen Don Quixote as a central theme because I believe that studying this type of character is essential in today's society. In a world that prioritizes rationality, power, and profit above all else, I am

drawn to figures like Don Quixote — reckless dreamers with kind hearts. Through my work, I aim to create a space where such individuals can connect and find resonance. This is the essence of my artistic language.

Q. What is your most cherished work?

Over the years, I have created so many pieces that it's difficult to recall each one. However, one work that fully embodies my "Don Quixote" theme is The Fake Kingdom of the Rhinoceros. This piece represents the disciplined,

unwavering journey of meditators and ascetics. While oxen typically have two horns, this work features only one, symbolizing the idea of following a singular path. The life of an ascetic shares many parallels with that of an artist, which is why the rhinoceros plays a central role in this piece. When I speak of a fake kingdom, I am referring to our present era — one where the boundary between reality and illusion has become blurred. In politics and society as a whole, we frequently question what is truly original and authentic. This piece reflects the world through the dual perspectives of an artist and an ascetic.

Q. What is your work in progress?

I'm currently working on two projects. Nowadays, most of my work is project-based and mainly occurs abroad. One of my forthcoming projects delves into the concept of "Sculpture of Dance." This AI-driven piece features EDM music,

dancers, and a collection of sculptures moving in perfect rhythm together. It's a form of kinetic art. This large-scale installation will showcase 30 to 40 sculptures arranged in clusters, moving in sync with the music, set within a vast ship repair facility. The accompanying video will depict the sculptures in motion, as if they are dancing. Additionally, I am developing a project that invites the audience into the space, a stark and unconventional setting. Another project I am working on is based on the concept of "The Forest of Sculptures." In Europe, expansive public squares are present in many cities. My goal is to create a sculptural forest in these squares, featuring sound trees and dance sculptures as the central elements.

Please scan the QR code to watch the sculptor's interview video.

Who is Sung Donghun?

He graduated from the Department of Sculpture at Chung-Ang University and received the Grand Prize at both the inaugural MBC Korean Figurative Sculpture Exhibition (1990) and the Gyeongin Art Exhibition (1990). In 2010, he was chosen as the representative artist for the Korean Pavilion at the Shanghai Expo. Additionally, he served as the lead artist at the Taiwan Ju Ming Museum (2011) and the Taiwan Dong-Ho Steel Foundation (2014).

He has participated in numerous sculpture symposiums and art project exhibitions across the globe, including in the UK, Germany, and the United States. Additionally, he has presented over 300 themed and solo exhibitions, notably featuring a solo exhibition of contemporary Korean artists at the Kunsthaus in Vienna, Austria, in 2009. His works are housed in over 120 locations, including the Seoul Museum of Art, Seonggok Art Museum, Gyeonggi Museum of Modern Art, Jeju Museum of Art, Busan Olympics Sculpture Park, Cheonan Arario Sculpture Park, Tatsukawa City Hall in Japan, Terricciola City Hall in Italy, Iwate Central Steel Mill in Japan, Zwickau Sculpture Park in Germany, and Changwon Sculpture Biennale at Yongji Park.

SENSITIVITY

Delightful Visual Play of Deconstruction and Construction :
Bahk Seonghi

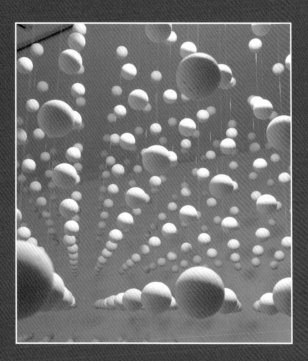

Bahk Seonghi's creations, sculptural in essence yet defying conventional boundaries, delve

between seeing and believing. His art introduces subtle disruptions between

what we perceive and what is actually visible, encouraging a reimagined perspective.

By navigating the interplay of material and mass, gravity and weightlessness, presence

and absence, the finite and the infinite, and the tangible and the virtual,

his work invites us to broaden our ways of seeing.

Choi Taeman / Art critic

Bahk Seonghi earned his bachelor's degree in Sculpture from Chung-Ang University in 1994 and continued his studies in Sculpture at the Accademia di Belle Arti Brera in Milan, Italy. Guided by a commitment to innovation, he has continuously sought out new possibilities while striving to maintain a universal resonance in his work. Despite his relentless exploration of new ideas and techniques, he discovered that many had already been uncovered in the West. This realization led him to seek a sculptural form that went beyond the traditional boundaries of sculpture. During this period, he became deeply preoccupied with the question of whether nature and culture were genuinely opposed to one another.

An Ink-and-Wash Painting in Space

While working with wood, a material embodying nature and deeply intertwined with culture, he developed a strong fascination with charcoal — the remnant left behind when wood is burned as kindling. Despite being the final transformation of wood, charcoal also carries a symbolic connection to the renewal of life. After trying various ways to work with charcoal, he eventually hung it.

Through this process, "Existence" was ultimately realized. Displayed in the 2001 exhibition *No Human* at the Arsenale Thetis in Venice, the piece involved suspending charcoal

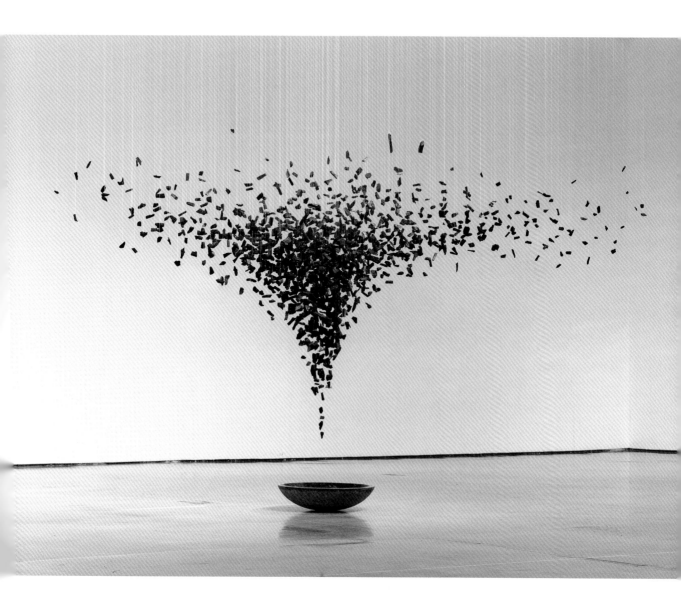

An Aggregation 1301

Charcoal, Nylon threads, etc.
(h)300, 400x100cm / 2013

Delightful Visual Play of Deconstruction and Construction : Bahk Seonghi 125

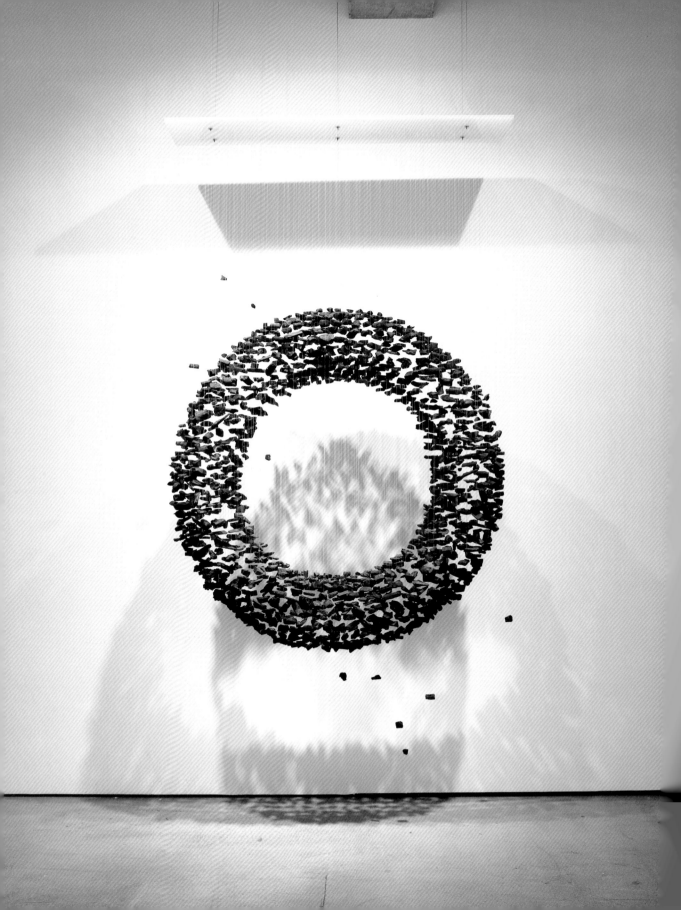

An Aggregation 0910

Charcoal, Nylon threads, etc.
(h)280, 144x32cm / 2009

fragments with nylon threads from the high ceiling of the indoor space, reconstructing the majesty of European columns at a height of 7 meters. Each individual piece of charcoal appears as a single dot, but when connected, they come together to form lines and planes.

This piece employs the fundamental artistic elements of dot, line, and plane to reconstruct the tangible form of a column. However, it stands out for its continuous composition of dots suspended in mid-air, seemingly defying gravity. While it occupies a defined space, it does not intend to obstruct the view like a solid mass. Instead, the gaps between the charcoal fragments and the vertically overlapping fishing lines create an architectural form that evokes a sense of illusion.

Additionally, the contrast between the densely suspended charcoal pieces and the more sparsely hung areas accentuates the column's contours while simultaneously arousing a visual impression of collapse and dissolution. This unfamiliar scene, formed by black dots, calls to mind the imagery of a three-dimensional Eastern ink painting.

This form, composed of countless dots or planes varying in size, appears to float within space while also linking different areas together. Following this, the

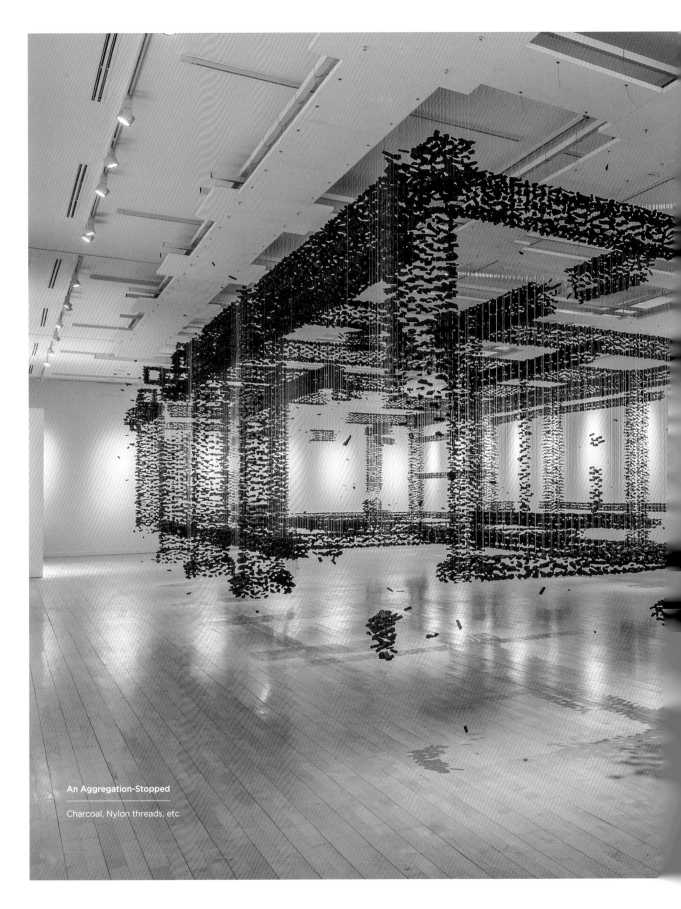

An Aggregation-Stopped

Charcoal, Nylon threads, etc.

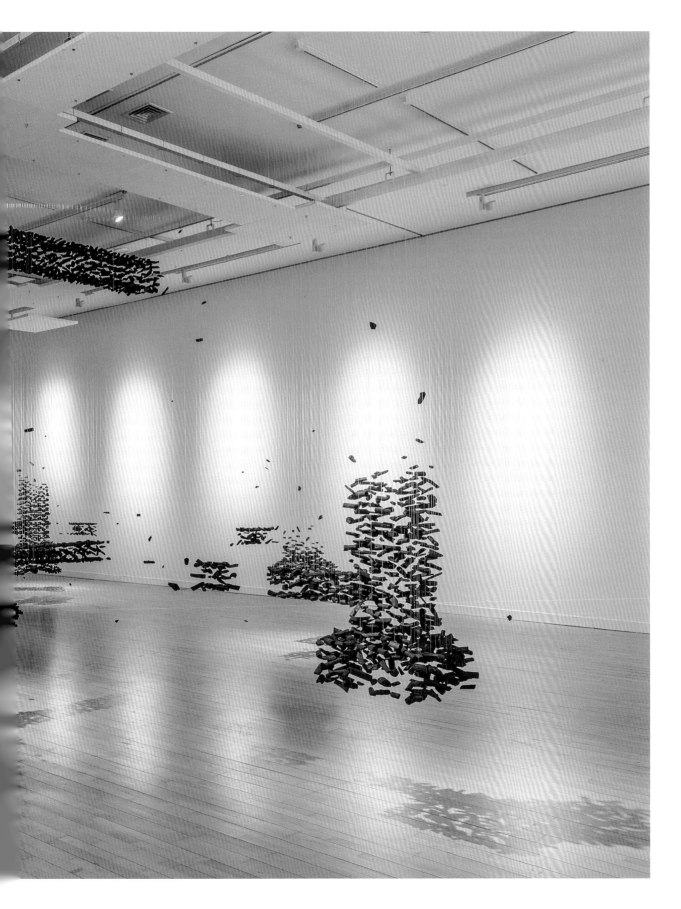

artist showcased similar installation works featuring architectural elements like columns, stairs, and arches in prominent exhibitions. He described these works as "the encounter between the natural and the artificial." By reconstructing weighty architectural forms from dots and surfaces, his pieces amplify the interplay of light and shadow while minimizing mass through the use of charcoal. They can be seen as architectural blueprints painted in space, or as interpretations of Eastern ink paintings.

The symbolism of charcoal plays a significant role as well. Similar to its use in traditions such as being hung on a straw rope during a baby's birth or placed in a soy sauce jar, charcoal is deeply connected to notions of cleanliness. In everyday life, charcoal is widely used to prevent spoilage, purify the air, absorb moisture, detoxify, and eliminate pollutants, all of which contribute to warding off evil and impurity. Bahk Seonghi's work, which replicates architectural forms, can be considered hygienic not from scientific grounds, but due to its connection to spiritual and symbolic meanings.

Existence 2001

Charcoal, Nylon threads, etc.
(h)700cm / Arsenale Thetis,
Venice / 2001

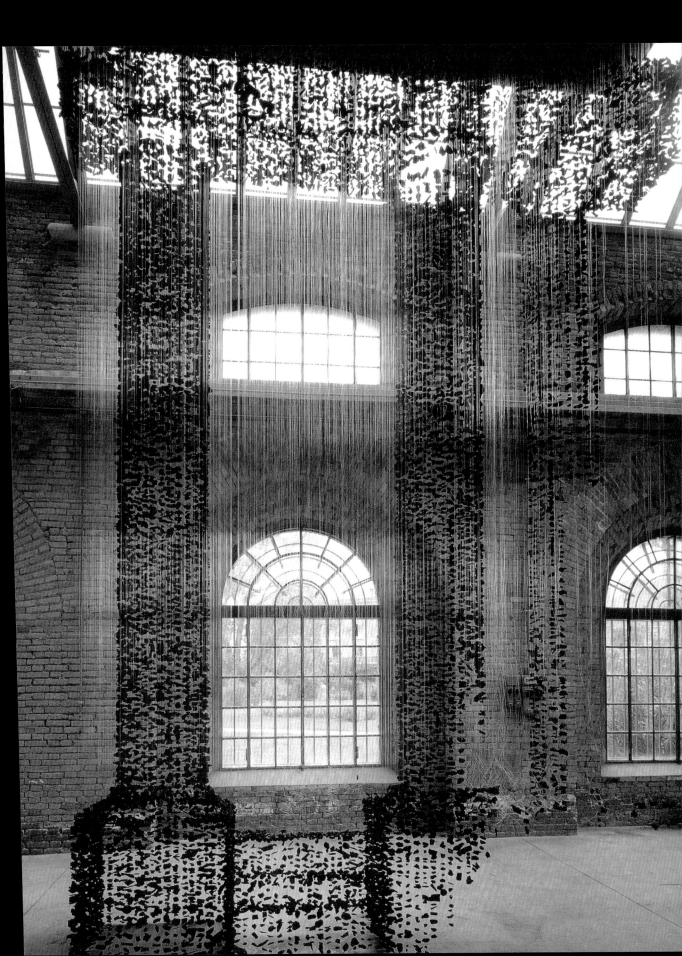

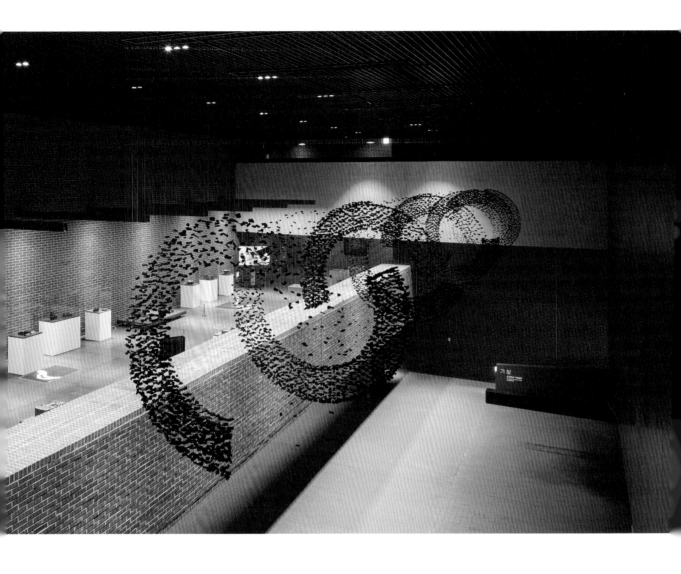

An Aggregation 190501-Time

Charcoal, Nylon threads, etc.
300x1500cm
Seosomun Shrine History Museum,
Seoul / 2019

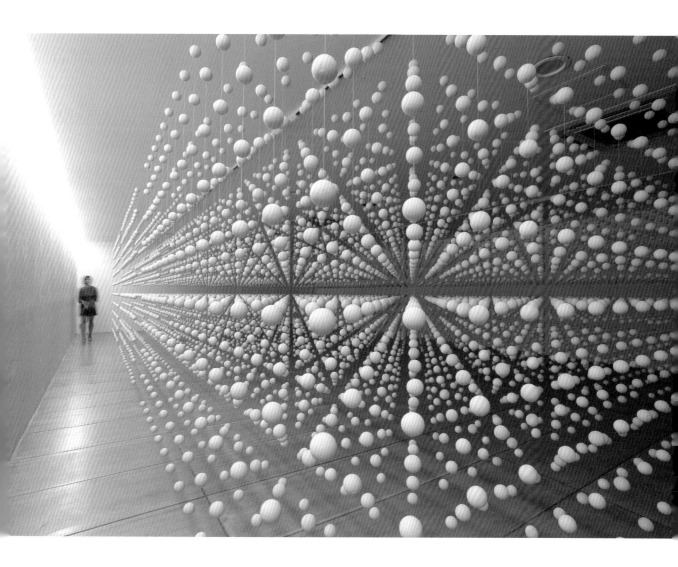

An Aggregation-Agravic

Styrofoam, Nylon threads, etc.
(h)230cm
Indang Museum, Daegu / 2019

Delightful Visual Play of Deconstruction and Construction : Bahk Seonghi

Visual Perturbation or Visual Play

Bahk Seonghi's primary themes can be broadly grouped into categories such as "Existence," "Aggregation," "Point of View," "Play of Infinity," and "Slice of Sensitivity," which are largely reflected in the titles of his works. Specifically, his charcoal-hanging pieces, which began in the late 1990s, are linked to Existence in the early 2000s, leading to the development of *An Aggregation*. In *An Aggregation*, the material transitions from charcoal to plastic beads, and the spatial complexity becomes more apparent. In the *Existence* series, the columns hang suspended in mid-air, never touching the ground, creating a sense of instability. The circular or rectangular shapes are imperfect, with some parts appearing fragmented. This ongoing process of deconstruction and reconstruction is a prominent feature in *An Aggregation*.

Notably, the installation inspired by the Seokgatap pagoda motif, shown at the 2015 *View-tiful* exhibition at the Wooyang Museum of Contemporary Art, alters its form based on the angle of the viewer's perspective. Nevertheless, the work reveals the true nature of the pagoda from specific angles. These volumes intersect and overlap, perturbing perception or resembling distorted shapes, much like shadows cast on the surface of water. However, this perturbation of perception, once completing

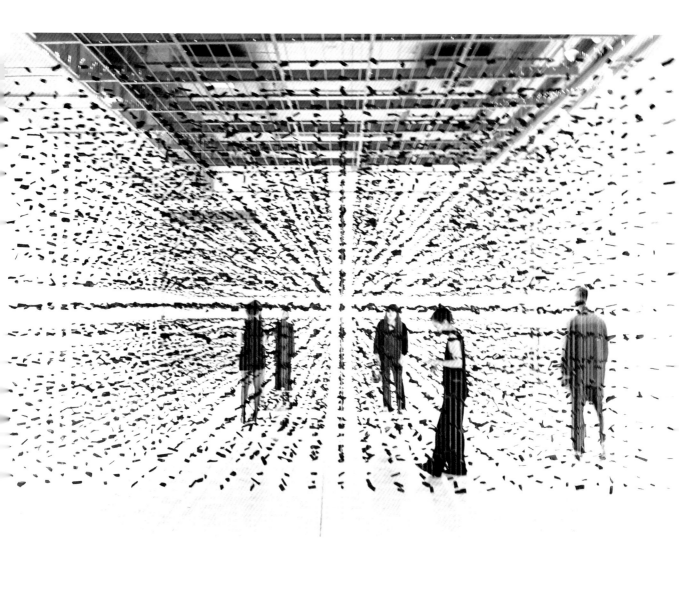

An Aggregation-Space

Charcoal, Nylon threads, etc.
(h)350cm / 2023

a full rotation, reaches a point where it stabilizes, as if multiple components combined to form a single shape, unveiling the form of the pagoda and restoring balance.

In front of this installation, the eye, as one of the sensory organs, does not serve as the ultimate authority in determining the object's nature. It is only by immersing oneself within the object that its complete form fully comes into view. Here, we can observe Bahk Seonghi's recurring use of tricks or visual play.

This quality is also evident in the work *An Aggregation – Time Stopped*, presented at the Busan Museum of Art in 2019 as part of the *Repetition and Difference* exhibition. The structure, composed of columns, beams, and purlins — fundamental components of traditional wooden hanok architecture — seems to float in mid-air. This form suggests a desolate landscape, reminiscent of walls scorched by fire. While the fragility of the structure evokes a feeling of impending collapse, potentially leading to the devastation of extinction, we are still able to walk into this reproduction, which is scaled to its actual size. As one walks through the artwork, it becomes hard to ignore the feeling that it represents not just a metaphor for life and death, but rather the process of disappearance and renewal in a state of temporary suspension. In this,

it becomes clear that the artist's focus extends beyond material and structure, delving into the ideas of perception and visibility, reality and illusion, existence and time.

Seeing Anew in the Realm of Optical Illusions

Bahk Seonghi's installation, where plastic beads are suspended, draws us into an optical illusion that mimics the sensation of our vision being drawn into a boundless space. By filling the space with beads, the artwork offers varying visual experiences based on direction and angle, creating a space with volume but devoid of mass. In this piece, our bodies are both filled and pulled into an empty space. It creates an illusion similar to being in a room where the interior of a cube is reflected, making our bodies multiply and appear to be drawn toward a vanishing point. Similarly, his artwork captivates our attention, leading our gaze beyond the vanishing point where the white dots converge into an infinite dimension.

Simultaneously, as the suspended objects impart a sense of volume to the space, our gaze slides into it, encountering the barrier formed by the beads, leading to a unique dual experience of perceiving a virtual mass.

Bahk Seonghi's creations, sculptural in essence yet defying conventional boundaries, delve between seeing and

believing. His art introduces subtle disruptions between what we perceive and what is actually visible, encouraging a reimagined perspective. By navigating the interplay of material and mass, gravity and weightlessness, presence and absence, the finite and the infinite, and the tangible and the virtual, his work invites us to broaden our ways of seeing.

This allure is an integral aspect of the appeal of his work.⊗

An Artist Who Creates Installations by Hanging Pieces of Charcoal : Bahk Seonghi

Suspending charcoal in midair to form huge structures with a focus on creating mobiles with hanji.

Q. What inspired you to focus on charcoal?

When graduating from university, it's common for aspiring artists to seek out their own materials or themes. At that time, no matter how much I thought about it, I couldn't figure out where to begin. So, I decided to start by identifying what I personally liked. I wanted to explore the relationship between nature and humanity. To do that, I needed to choose something that symbolized nature. As I listed my favorite things, "wind" came to mind. However, I quickly realized it wasn't quite the right choice. I found it quite challenging to express the idea, so the next things that came to mind were mountains and trees. That's when I decided to make wood my primary material. As I worked with wood, charcoal naturally followed. Charcoal is what remains after wood burns, leaving only carbon. That's how I began using charcoal in my work.

Q. How did you come to create
suspended sculptures instead of
standing ones?

I tend to think in terms of verbs. When creating a piece, I first consider how it should be displayed — whether it should be hung on a wall, placed on the floor, suspended, or buried underground. As I continue considering these options, I eventually arrive at a realization. Out of all the possibilities, I chose the verb "suspend." From a human perspective, we often focus on things below the two-meter mark, but as we look upward, the space above becomes increasingly empty. This becomes even more noticeable with taller buildings. Initially, I experimented with suspending stones. I hung countless small stones, but I soon realized that to suspend just one ton of stone, I would need nearly ten tons of steel structure to support it. It felt like the effort outweighed the result. Recognizing that this approach was impractical, I searched for a more efficient alternative and eventually turned to suspending charcoal instead. Unlike stone, charcoal is much lighter and, even if it falls, it poses minimal risk to people. From my perspective, this was a more logical choice that also significantly reduced safety concerns.

By incorporating natural materials into my installations, I deeply reflect on the relationship between humans and nature — how we can coexist, how we should live in harmony, and what kind

of mindset we should adopt toward nature. I hope my work encourages viewers to engage in a dialogue about our connection with the natural world.

Q. What are your plans for your next work?

I recently completed *Manineuichong*, an installation in Namwon. One of my works, *An Aggregation*, features small sculptures coming together to form a larger whole, and *Manineuichong* similarly symbolizes the collective strength of individuals uniting as one, aligning with the same conceptual framework. In October 2025, I have a solo exhibition planned in Paris.

Please scan the QR code to watch the sculptor's interview video.

Who is Bahk Seonghi?

Born in 1966 in Seonsan, Gyeongbuk, Bahk Seonghi completed his bachelor's degree in Sculpture at Chung-Ang University before furthering his studies in Italy, where he earned a degree in Sculpture from the Accademia di Belle Arti Brera in Milan. He primarily carried out his artistic career in Europe, including Italy, and started receiving recognition in South Korea after his solo exhibition in Seoul in 2003. In 2005, after being chosen as one of the "Today's Artists 2005" by the Kim Chong Yung Museum, Bahk Seonghi's solo exhibition drew attention for his innovative installation works. He presented pieces that introduced a fresh approach to perception through distorted perspectives in relievo based on perspective, alongside works featuring suspended charcoal to construct architectural structures within space.

He has held solo exhibitions in various cities worldwide, including Lisbon in Portugal, Córdoba in Spain, Los Angeles in the USA, as well as multiple cities across Asia. In Korea, his solo exhibitions include *View-tiful* in 2015 at the Wooyang Museum of Contemporary Art in Gyeongju, *Walking into Light* in 2017 at the MOA Museum in Gonjiam, and an exhibition at the Kim Sechoong Museum in 2018.

SOAP

A Transcendent Aesthetic That Blurs the Boundaries of Time:
Shin Meekyoung

Shin Meekyoung's artistic sensibility evokes a synesthetic relic of time, reinterpreted

through diverse sculptural languages shaped by culture. Her works transcend temporal

boundaries, offering simple, clear, and original responses to the fundamental question:

"What is art?" They embody the wisdom of how to navigate and harmonize differences,

exploring the interplay between creation and distinction, sorrow and joy,

discord and unity, as well as the past and present.

Kim Yoonsub / Art critic

"Can I touch this?" "I don't think so — it's an exhibit!" "Wait, look! It says, 'Try washing your hands with the angel sculpture by the sink. Feel free to touch this piece as much as you like!'" "Then I'll rub the little angel's face and wash my hands!"

At the restroom sink in the Buk-Seoul Museum of Art, two middle-aged men were engaged in an unexpected discussion. The reason was Shin Meekyoung's artwork, *Toilet Project 2024*, installed on either side of the sink. As they noted, the angel-shaped sculpture was made of soap. Shin is widely recognized as a "contemporary artist" who has "translated" the cultural values of Eastern and Western civilizations into "soap sculptures." For nearly 30 years, since 1996, she has remained dedicated to working with soap. But why soap, out of all materials? The story goes that one day, she noticed a pink soap in a school restroom, and to her, it resembled pink marble. This moment became a turning point in her artistic journey.

Soap is a highly ambiguous and intriguing material. Though typically solid, it has a soft, delicate quality and a pleasant scent. Its bubbles are equally significant, symbolizing transience. The way a solid bar dissolves into fleeting bubbles serves as a powerful metaphor for life's evanescent nature and mortality, much like the themes

Large Painting Series 005
Frame, soap, fragrance and colorants / 201×160×5cm / 2023

found in Vanitas paintings. This genre of still-life painting emerged in 17th-century Netherlands and Flanders, influenced by tragedies such as the Black Death and religious wars. Often featuring symbols like skulls, candles, and flowers, these works depict the impermanence of life. The Latin term "Vanitas" translates to "futility" and originates from the opening words of Ecclesiastes 12:8 in the Old Testament: "Vanity of vanities, saith the preacher, all is vanity." Interestingly, soap is a recurring element in Vanitas still-life paintings.

Soap Sculptures that Have Solidified Time

Shin Meekyoung's soap sculptures can be viewed as a modern example of "Vanitas sculpture." This is evident in her recurring reinterpretation of historical artifacts and depictions of scenes from ruined sites. The artist herself has explained, "When we visit ruins, we envision the "things that have vanished" by observing what remains, which takes us on a journey through time. I capture this 'visualized temporality' in my works." Shin Meekyoung's works convert time, which flows like liquid, into a tangible form. In a way, her pieces become artifacts. These creations were not formed from the beginning of time but are the culmination of its passage across various civilizations and the layers of their paths. By using soap as

Celestial Whisper

The view from Shin Meekyoung's
Solo Exhibition at Buk-Seoul
Museum of Art
Like the Transparent and Fragrant
Wings of an Angel /
June 4, 2024 – May 5, 2025

A Transcendent Aesthetic That Blurs the Boundaries of Time : Shin Meekyoung 147

Celestial Whisper : Angel

The view from the angel soap
sculpture installation from Shin
Meekyoung's Solo Exhibition at
Buk-Seoul Museum of Art
Like the Transparent and Fragrant
Wings of an Angel /
June 4, 2024 - May 5, 2025

Translation Series :
Fragrance Vessel

The ceramic soap sculpture
installation view from Shin
Meekyoung's Solo Exhibition at
Buk-Seoul Museum of Art
Like the Transparent and Fragrant
Wings of an Angel /
June 4, 2024 - May 5, 2025

a medium, she has crafted a powerful piece that naturally raises fundamental questions about human history and existence.

Though the work was completed contemporarily, it exudes a transcendent aesthetic that seems ready to dissolve the boundaries of time. This is why Shin Meekyoung is often referred to as an "alchemist of time," capable of guiding the flow of time. Exhibition titles such as *Like the Transparent and Fragrant Wings of an Angel*, *Time/Material: A Museum Full of Vibrancy*, and *Gone Yet Still Existing* all reflect this same concept. These titles hint at the artist's intention to highlight not what is fading or fully existing, but the "gap where contact occurs." As a result, these make it easier for us to grasp the artist's ideas or message.

An exhibition titled *Weather* at the Barakat Gallery in London in October 2018 serves as a noteworthy example. The show featured new soap ceramics alongside ancient artifacts from the Barakat Collection. But why was the title *Weather* chosen? It was meant to capture the dual meanings of "weather": the verb referring to the process by which objects age and wear over time (weathering), and its noun form as a metaphor for transcendent time and its ever-changing nature (weather/meteorological conditions). A prominent piece from this exhibition was the *Megalith*

Large Painting Series 003

Frame, soap, fragrance and colorants / 201×160×5cm / 2023

Toilet Project : Angel 2024

The installation view from Shin
Meekyoung's Solo Exhibition
2024 Toilet Project at Buk-Seoul
Museum of Art.
The "Little Angel Sculpture"
positioned on the washbasin in
the restroom. This sculpture, also
crafted from soap, invites visitors
to interact with it by rubbing it
and using it to wash their hands.

Series, in which fragments created by an explosion during the clay hardening process in the kiln were re-fired into ceramics. Much like a star that holds the secrets of the universe's creation, these pieces captured and documented the precise moment of the explosion. It was yet another method of visually preserving the layers and textures of time.

Aphrodite Reborn in Soap

Soap has a long history, with references found in Egyptian murals and the Old Testament. It is thought to have originated from an ancient Roman ritual in which sheep were burned at an altar on a hilltop called "Sapo" as an offering to the gods. After the ceremony, a cleaner would take the leftover ashes home and use them to wash clothes in water mixed with the ashes, discovering that the stains were easily removed. This occurred because the melted sheep fat during the burning process was absorbed into the ashes. The name of the hill, "Sapo," eventually transformed into the word "soap," which is the origin of the term we use today. In Chinese characters, its etymology traces back to the word "飛陋," meaning "to blow away dirt." Shin Meekyoung's discovery of soap as an artistic inspiration was a fortuitous and fleeting experience. It must have been a moment of insight, realizing that soap

was an inevitable, destined link for the artist, much like the discovery and creation of soap itself.

There are several instances that highlight Shin Meekyoung's ability to expertly work with soap as a medium and transform it into creative artistic creations. One example is the "six-month performance" she conducted while studying in the UK from 1996 to 1997. As she observed the restoration of an Aphrodite sculpture, she became interested in the moment when the piece functioned as contemporary art. Considering how Aphrodite is recontextualized in the present, she decided to recreate the image using soap. She transformed the white marble into Aphrodite's skin tone and hair color, then extended the project beyond simple replication by incorporating performance. By reframing ancient artifacts as contemporary art, her work explored the temporal and cultural distances that an East Asian artist navigates when engaging with the Western classical tradition. This serendipitous event not only stirred excitement at her school but also solidified her reputation as a significant figure in the London art scene. The concept of sculpting Venus (Aphrodite), the Greek goddess of beauty and love, out of soap, was a perfect match!

Another event took place in 2007. When the "Moon Jar" was temporarily removed from the Korean Gallery at the British Museum in London for a touring exhibition, Shin Meekyoung's "Soap Moon Jar" was installed in its place at the suggestion of a curator. This project resonated deeply with her artistic vision. Presenting a contemporary artwork within a museum dedicated to historical artifacts, and inviting visitors to engage with the "Soap Moon Jar" as a modern reinterpretation, fostered an irreplaceable experience. While the soap version might be seen as a replica or imitation from the perspective of the original "Moon Jar," within the context of contemporary art, it functioned as an original piece in its own right, bringing a fresh significance to the exhibition. Throughout the exhibition, visitors remained unaware that the "Moon Jar" was not an authentic porcelain piece but a "fake" one crafted from soap. What sets Shin Meekyoung apart is her ability to capture the true essence of the object, imbuing it with remarkable depth. Her impeccable technique, so precise that it can even deceive expert eyes, is truly impressive. Moreover, the unique appeal of soap — engaging the senses of smell, touch, and sight —adds an extraordinary dimension to her work.

Synesthetic Artifacts of Time

Alongside her sculptures and installations, Shin Meekyoung introduces a collection of abstract works called *Large Painting*, a series which also use soap as the medium. Despite being labeled "painting," it is essentially a "flat sculpture made of soap." Large amounts of soap in various colors are melted and poured into a large frame in a single motion, where it solidifies. The blending of these colors evokes the birth of a new world, creating a captivating and deep effect. This process and the final product mirror the dynamic energy seen in the expressive brushstrokes of painting.

Since her school days, Shin Meekyoung has demonstrated a remarkable skill in replicating almost anything. Her talent for crafting three-dimensional forms, along with her meticulous attention to surface details, consistently draws admiration. Her natural artistic abilities have found a perfect match with the unique material of soap, enabling her to convey even her innermost emotions. Shin Meekyoung's artistic sensibility evokes a synesthetic relic of time, reinterpreted through diverse sculptural languages shaped by culture. Her works transcend temporal boundaries, offering simple, clear, and original responses to the fundamental question: "What is art?" They embody a wisdom of how to navigate and harmonize differences,

exploring the interplay between creation and distinction, sorrow and joy, discord and unity, as well as the past and present. Her works have overcome the limitations of soap as a medium, which is highly vulnerable to environmental conditions, whether in galleries, museums, or public spaces. Her bold experiments and challenges constantly captivate and engage audiences.ⓚⓢ

An Artist who Sculpts with Soap : Shin Meekyoung

Soap is metamorphosed into an artifact: The elegant passage of its dissolution.

Q. Can you tell us about the unique sculpting material, "soap," which melts away?

Soap and marble have remarkably similar textures. When observing classical Western marble sculptures, one can notice the impressive precision and smoothness with which they are carved. During my time studying abroad, I initially thought marble felt akin to soap. It was just a fleeting thought at first. However, as I grew more conscious of my identity as a young Eastern artist among Westerners, I realized my work needed to emphasize these differences. Despite their similar appearance, I discovered that marble and soap are fundamentally different. Instead of debating the strength of soap versus marble, I felt that sculpting soap to mimic marble would best express my identity if I were to create classical sculptures.

Moreover, having journeyed from

Korea to a new and unfamiliar land, the fragrant quality of soap held symbolic significance, representing my ability to adapt and establish my originality in a new setting. Soap is, in essence, one of the most practical materials, yet it is rich in symbolism. It cleanses impurities, but what fascinated me most is its nature of dissolving. While all things eventually fade and change, soap stands out as the most universally recognized and apparent symbol of vanishing. Thus, the primary element I focus on in using soap is the experience of disappearance. We typically expect cultural artifacts or artworks to last, not to simply vanish. By crafting them from soap — a material that easily fades away — I aimed to create a psychological contradiction.

Q. What are your thoughts on audiences using and potentially damaging your soap sculptures?

The audience's interaction might be perceived as damaging the artwork, but I see it as part of the artifact creation process. Countless individuals are born and pass away in this world, and we exist within that cycle. Cultural artifacts serve as evidence of "having lived," and we visit museums and galleries to view them. However, we know that these works were not initially intended to become museum relics. Every artifact serves a purpose, has a function, and follows a lifespan. However, once it is placed in a museum for exhibition, its role and the passage of time become suspended. Likewise, when I sculpt soap and position it in a restroom, it exists both as a functional soap and as an aesthetic object that enhances the space. As people interact with it, they actively contribute to its history — some may carve their names into it, while others might alter its form through use

or damage.

On the other hand, once a bar of soap is placed in an exhibition hall, no one would use it to wash their hands. The moment it enters a museum, it loses its practical function and instead becomes a work of art. What was once a soap sculpted to resemble an artifact now transitions into an artifact in its own right. In doing so, it challenges perceptions and invites reflection on the true nature of an artifact. What stands out is the idea of making something familiar feel new once more. In my Toilet Project, I produce multiple identical pieces and distribute them to various locations. As time passes, each piece, though originally the same, undergoes distinct changes. This experiment highlights how every work ultimately becomes unique, which I find truly fascinating. In the Toilet Project, my creations are only 49% finished — the remaining 51% is completed as the pieces travel and return. Occasionally, I collect these returned works for a new project or re-exhibit them. The distinct transformations of each piece over time are often intriguing, as the audience's interaction helps to complete the artwork.

Q. What message do you want to convey by bringing historical objects into the present?

I regard artifacts as entities that "become" rather than as things that are "made." After all, artifacts were not originally created to be considered as such. I want viewers to sense the temporal and spatial gap when they observe these sculpted relics. My goal is not to simply recreate ancient artifacts as sculptures, but to reconstruct time in the present, allowing viewers to experience the time lag between past and present. By sculpting Western artifacts for exhibition in the East and vice versa, I want to reveal the intersection of space and time.

Who is Shin Meekyoung?

Shin Meekyoung obtained both a B.A. and an M.A. in Sculpture from the College of Fine Arts at Seoul National University. She furthered her studies with a Master's degree in Sculpture at the Slade School of Fine Art and another Master's in Ceramics & Glass from the Royal College of Art in London. In 2013, the National Museum of Modern and Contemporary Art nominated her for "Artist of the Year."

Shin Meekyoung is an acclaimed mid-career artist with notable accomplishments both in Korea and abroad, including receiving the "Monaco Principality Award" at the International Contemporary Art Fair in Monaco.

In 2004 and 2007, Shin Meekyoung was invited to exhibit at the British Museum, presenting works that reinterpreted Greek and Roman sculptures in a contemporary context. Over the years, she has held more than 35 solo exhibitions at distinguished art institutions, such as the Princessehof National Museum of Ceramics in the Netherlands, and the Barakat Gallery in London. She has also taken part in numerous group exhibitions, including the main exhibition at the Venice Biennale. She remains actively involved in the international art scene, dividing her time between London and Seoul.

Please scan the QR code to watch the sculptor's interview video.

EGO

An Approach to the Source of Existence with Minimal Material :
Park Seungmo

The essence of Park Seungmo's work is found in his exploration of boundaries — the act of erasing and creating — transforming an object's form into something entirely new and meaningful. In his piece titled Illusion, he delves into the spaces between reality and virtuality, past and present, life and death, progressing toward a deeper understanding of impermanence that blurs the distinction between what is real and what is unreal.

Kim Jinyub / Art critic, Director of the Korea Visual Arts and Culture Institute

In Park Seungmo's studio, three-dimensional sculptures crafted from intricately wound wire are displayed. Alongside them, wire and metal mesh images are suspended on the walls or in mid-air. On one side of the space, a wall appears to have been dug out and crumbled. The artist conveys landscapes and human forms through sculptural works that combine wire and metal mesh in a painterly way. This method challenges traditional notions of what constitutes an art piece, introducing a unique sculptural technique. These creations, which merge phenomena with essence and reality with fiction, stem from his inner vision and generate an existential space that exists at the intersection of life and art.

The wire sculptures that began in the 2000s involve wrapping wire around synthetic resin cast from real objects, imbuing these objects with new meaning. Pieces like *Grand Piano* and *Winged Victory of Samothrace* obscure the original forms, transforming them into entirely new creations through the use of the wire technique. The essence of these works lies in faithfully capturing the shape of the object yet transforming it into a completely new material with a different significance — a process of erasing and creating occurs at the boundaries themselves. In his piece titled *Illusion*, he delves into the spaces between reality and virtuality, past and present, life

Winged Victory of Samothrace

Aluminum wire, fiberglass /
147×174×229㎝ /
Incheon Paradise City / 2018

Grand piano

Aluminum wire, fiberglass, life
casting / 180×151×180㎝ / 2004

and death, progressing toward a deeper understanding of impermanence that blurs the distinction between what is real and what is unreal.

The method in *Illusion*, which hides the object to create something new, examines the relationship between the object and the self. Additionally, the artist merges the object with the surrounding forms that encase it, drawing them into the realm of his inner reflection. From this process, a new horizon emerges, embodying the very essence of Park Seungmo's work. His distinctive approach to art stems from a personal and deep exploration, rather than being rooted in art historical traditions. The origin of this tendency can be traced back to his travels to India after graduating from university.

The Primordial Impermanence Discovered in the Mandalas

After graduating from university, Park Seungmo chose to travel to India instead of pursuing the popular option of studying abroad at the time. The artist explained that he made this choice because he believed that studying abroad wouldn't change his creative process.

His stay in India for more than five years had a substantial influence on both his life and his art. A notable experience was his encounter with Tibetan Buddhism. During his travels, he visited a Tibetan Buddhist monastery in exile in India. There, he was fortunate enough to witness monks creating mandalas — a Sanskrit term and a Buddhist concept. In Buddhism, mandalas are circular images symbolizing the virtues of the universe and the Dharma realm — with sand.

The monks were crafting mandalas with sand on a large table, a process that resembled both a painstakingly meticulous task and a profound spiritual practice. After dedicating significant time and effort to meticulously constructing the mandalas, the senior monk would perform a final inspection and then, without hesitation, sweep the entire creation away. The astonishment didn't stop there. Without a single word of complaint, the monks would regroup and begin the repetitive process all over again.

Observing this process, Park Seungmo gained exceptional insight into the essence of life and art. It was akin to embarking on a quest to locate a lost shadow, only to discover that no matter how diligently one searches, the shadow remains elusive. While traditional art encapsulates

Ego
Stainless steel wire /
196×88×70㎝ / 2018

Absence

2014

human finitude through material imagination and imparts meaning through symbols, it falls short in fully expressing the fundamental impermanence of human existence.

Traditional sculptural materials like clay, stone, and metal possess inherent "materiality," but their physical form and mass impose constraints that prevent them from surpassing these physical constraints. In response, Park Seungmo employs wire and metal mesh — minimal materials — to explore the concept of fundamental impermanence. This choice reflects a process of minimizing the "self" within his artistic practice.

Similar to the Buddhist notion that differentiating between matter and emptiness is ultimately void, Park Seungmo's "ego" exists as a presence suspended on the boundary, neither fully belonging to the material nor the immaterial. However, this does not mean that ego is defined as a "manifestation" of "emptiness" or "void."

To minimize the ego is to deliberately strip away artificiality in the creation process, allowing the artwork to occupy an open space and encouraging the realization of true freedom. This can only occur when the ego resides at the threshold between phenomenon and essence. When the ego immerses itself in the current flowing between the

Insight into the true nature of reality

Fiberglass / 300×80×276㎝ /
Saasfee Pavilion, Frankfurt, Germany /
2018

duality of emptiness and solidity, the origin of existence naturally reveals itself.

The Insight into the True Nature of Reality

This method of utilizing minimal materials has been further developed in the artist's recent installation pieces like *Absence* (2014) and *Maya*. In his 2022 solo exhibition *Everything and Nothing*, Park Seungmo's sense of self deepens.

While walking the streets of Manhattan, he accidentally observed the reflection of both the interior and exterior of a building in a coffee shop's glass window. This moment was captured and expressed through multiple layers of wire mesh, resulting in the *Window* series, a collection of nine pieces. This series combines the artwork's fundamental significance with the connection between the artist and the viewer, merging them into a unified horizon.

This type of installation work powerfully amplifies the concept of "illusion" through the use of lighting projected from behind the artwork, causing the image to fade or inviting the viewer to step into the piece itself. This effect arises from the artist's awareness of the boundaries where the self exists. The "illusion" technique, which transforms

the object into transcendental awareness by eliminating the artificial constructs of understanding, allows for a freer interpretation. This method embodies the artist's desire to contemplate human finitude and convey it through a fresh artistic language.

His artwork *Insight into the True Nature of Reality* (2018) reinterprets the walls of ancient European ruins through real-image prints, offering a new sense of weight and presence compared to his earlier wire and mesh pieces. This work seems to encapsulate a culmination of the diverse evolutions found in the artist's previous creations.

The crumbling ruins symbolize the contrast between the real and the virtual, longing and lamentation, tranquility and uneasiness. Although invisible to our sight, the walls of these ruins embody many realities that have passed through them, serving as a metaphor that foreshadows the future world. Through these walls, the artist seeks to not only give form to the fragile world of existence at the boundary but also overcome the abstraction of returning to ideals.

Ultimately, Park Seungmo's work centers on the reality that conceals its true substance, striving to reach the authentic nature of reality — the origin of existence. Since the

mirror-like world of phenomena is but a fleeting reflection, profound meditation and introspection are necessary to transcend it.

Park Seungmo's work, which examines reality through boundaries and delves into the essence of existence, now aims to transcend the passage of time. This is because it is within this flow that one can uncover a genuine artistic space that surpasses the illusion of reality and the finitude of being.Ⓚ

Maya2078

Stainless steel mesh /
295×484×14cm / 2017

The Seeker of
the Origin of Existence :
Park Seungmo

A way of transforming the unconscious into the conscious: Visualization of errors in perception through sculpture.

Q. What led you to choose wire and wire mesh as your medium of expression?

In 1997, while staying in India, I had the chance to observe the Tibetan mandala-making process in Dharamshala, a town in the Himalayas. Mandalas are crafted using vividly colored sand made from ground stone powders. The sand is carefully poured through copper funnels called "cornetts" and delicately tapped to create intricate designs.

After weeks of meticulous effort, the process culminates in a purposeful and sudden destruction of the completed patterns. The deliberate destruction of something painstakingly crafted in an instant fascinated me in my twenties, drawing my attention to the realm of sculpture that embraces fragility and impermanence rather than solidity. This led me to create my first piece using aluminum wire, wrapping it around sculptural forms and securing

it with a weak adhesive instead of durable welding, allowing for easy detachment. For my solo exhibition in London, I unwrapped all the precisely wound wire that had arrived just a day before the opening, installing only the wire itself. Later, I experimented with layering multiple sheets of wire mesh, utilizing backlit shadows to create images in a more two-dimensional manner.

Q. How did your time in India shape your experiences?

While studying Western art history at university, I felt a deep desire to explore knowledge from within, rather than expanding outward into the growing landscape of contemporary art. To pursue this, I believed it was best to step away from artistic practice for a few years and turn my focus inward. Although I cannot say I discovered anything definitive, my perspectives shifted profoundly through lived experiences rather than theoretical study. After returning to Korea, I committed to forging my own path and putting my insights into practice.

Q. How did you find inspiration for your new work?

In 1997, a sketch naturally emerged amid a flurry of fleeting and intersecting thoughts. However, bringing it to life required specific environmental conditions that weren't in place at the time. I wasn't ready to embody the idea back then, but over the course of more than 20 years, external circumstances gradually aligned, making it possible to finally bring the sketch into reality. My goal is to explore ways to turn the unconscious into the conscious and to sculpt visual perception errors, translating these concepts into tangible form through a practical approach.

Please scan the QR code to watch the sculptor's interview video.

Who is Park Seungmo?

Born in 1969 in Sancheong, Gyeongnam, Park Seungmo earned a B.A. in Sculpture from Dong-A University in Busan. In the mid-1990s, he traveled to India, where he spent approximately five years immersed in meditation and spiritual practice.

Since his debut solo exhibition in 2005, Park Seungmo has showcased his work in numerous exhibitions across China, Taiwan, the United States, and Germany. To support his artistic journey, he has established studios in several major cities worldwide, including New York, Berlin, and Seoul.

In 2009, Park Seungmo participated in an exhibition at Saatchi Gallery in London, UK. In 2010, he exhibited at the Gyeonggi Museum of Modern Art in Ansan, Korea.

In 2014, he exhibited at the MOCA Taipei, Taiwan, and the Dennos Museum Center in Michigan, USA. In 2015, he participated in exhibitions at Kendall College of Art and Design and Grand Rapids in Michigan, USA. In 2016, his works were displayed at Bergdorf Goodman in New York, USA.

In 2018, he exhibited at Saasfee Pavilion in Frankfurt, Germany. In 2019, he held an exhibition at Lotte Museum in Seoul, Korea. In 2021, he showcased his work at Tang Contemporary Art in Hong Kong. In 2022, he took part in solo and group exhibitions at Space Hohwa in Seoul, Korea.

EMPTY

Collector of Memories,
the Image Capturer :
Koh Myungkeun

Koh Myungkeun's photographic sculptures are marked by empty spaces and layered
images and narratives. They evoke the paths of memories, offering the space for us
to recall our own memories of the past and move freely across the boundaries of concepts
and visual images. The transparent empty spaces eventually take on
a fresh significance, shaped by the perspectives of those who observe them.

Kim Suejin / Art critic

"Through the sense of emptiness within the image boxes, I aimed to express the idea that the world is a 'Shadow World,' composed solely of images. The act of 'seeing' that I intended is actually seeing the 'emptiness.' This emptiness isn't visual but relates to a lack of content. As such, it becomes a void that the viewer's imagination fills, independent of the artist's original intention." - Koh Myungkeun

The Fusion of Sculpture and Photography

Koh Myungkeun's transparent photographic sculptures create a captivating effect as the images shift with each change in viewing angle. The play of light on the transparent polyhedron crafted from thin plastic sheets (plexiglass) forms multiple layers of images, revealing a unique space that evokes cinematic scenes.

As viewers shift their perspective, they are drawn to pause in front of the artwork, almost as if trying to uncover the artist's intent through the overlapping images that create subtle textures. However, one might reasonably question whether the artist's purpose is solely to evoke a visible effect with the image. At the same time, this raises curiosity about the deeper message the artist aims to communicate beyond the splendid scenes.

Air-4

52×3×29cm /
Digital Film 3D Collage / 2007

Koh Myungkeun is renowned for his "photographic sculptures," which blend photography with three-dimensional art. After studying sculpture in Korea, he moved to New York in the late 1980s to further his education and explore the realm of photography. By combining his sculptural expertise with photography, he became a pioneer in the field of photographic sculpture. Although he was deeply concerned about his identity as a sculptor, his journey began with the simple idea of combining the three-dimensional and the two-dimensional.

Through recognizing the distinctiveness at the intersection of sculpture's historical nature and photography's temporal essence, Koh Myungkeun discovered a third realm that transcended the limits of both mediums. In the early stages of his work, he created "opaque and heavy sculptures" by affixing photographs printed on paper to wooden or metal structures and coating them with resin. This was the beginning of his photographic sculptures. However, since the early 2000s, his focus has shifted to works centered around "empty, transparent spaces," exploring the interplay between images and space from diverse perspectives.

Blue building (New York)

110×52×37cm /
Digital Film 3D Collage / 2024

Chongqing 18-5 (Chongqing)

90×23×5cm /
Digital Film 3D Collage / 2022

The photographs he took from around the world are printed onto transparent OHP film, then layered and pressed between multiple sheets of plexiglass, giving them a three-dimensional form. Furthermore, just as important as blending heterogenous mediums, the artist faced the difficult challenge of seamlessly integrating these disparate materials into a polyhedral structure. After many trials and errors, Koh Myungkeun developed a technique for securely joining the plastic panels by melting their edges with a heated soldering iron. This innovation resulted in the creation of his current photographic sculptures, which embrace empty space.

The "Image Capturer" who collects memories of life

Generally, photography is linked to the idea of reproduction, but Koh Myungkeun sees it as something deeply connected to the reality we live in, describing it as "a compression of space." This distinctive perspective has brought him recognition in renowned venues both in Korea and abroad. Even now, he continues to identify as an "Image Capturer," staying busy collecting images that follow the flow of his thoughts, from everyday settings to historical landmarks.

Colosseum of Brooklyn

52×44×35cm
Photos, Wood, Plastic / 1992

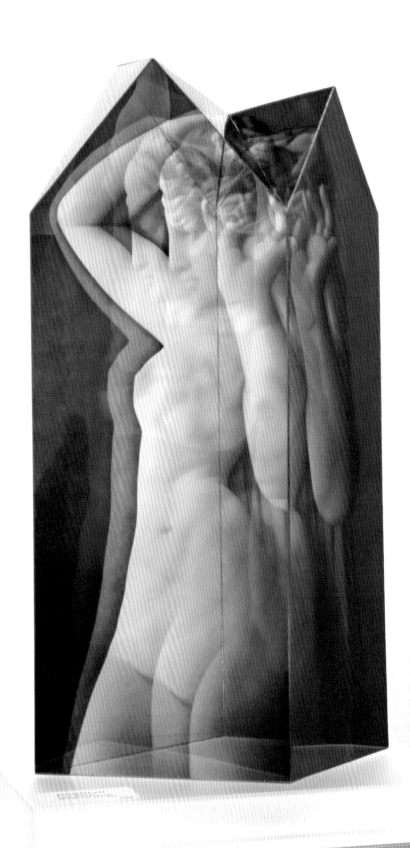

The photographic sculpture series started with the *Building* series, which featured striking architecture captured during his time studying in New York. In the 2000s, he began incorporating natural imagery, conveyed through curved surfaces, and called it the *Nature* series. Around the same time, he also introduced the *Body* series, which focused on sculptures he encountered in art museums worldwide. This series marked a pivotal moment for the artist, allowing him to rediscover the beauty of the human form as a sculptor. Recently, Koh Myungkeun has reexamined the relationship between tridimensionality and space from a fresh perspective, using natural imagery as a backdrop. In the *Trilogy* series, the artist deconstructs polyhedral structures, decreasing depth to transform them into two-dimensional forms, while reassembling specific themes from multiple viewpoints. Throughout this series, he cultivates a renewed understanding of space, unveiling a unique approach where sculptural imagination and photography are effortlessly blended.

A crucial aspect of his photographic sculptures involves gathering images from multifarious locations. Over the past thirty years, he has amassed approximately 300,000 photographs by traveling to various places around the globe like New York, San Francisco, Beijing, Tianjin, Chongqing, Hong Kong, and Vietnam, as well as across

Stone Body 37
74×40×25cm
Digital film 3D-collage / 2007

Europe, including the UK, Italy, France, and Spain. According to the artist, he doesn't establish a specific theme or goal beforehand when collecting images. Instead, he envisions new works while building an archive of the amassed images. This approach enables him to gather a vast array of images and choose from this diversity to develop his projects.

As reflected in his extensive photographic journeys, Koh Myungkeun avoids abstract images, focusing instead on capturing spaces that convey a sense of tangible reality. Additionally, he strives to fully express the colors brought forth by the atmosphere at the moment the photo is taken. His goal is to encourage viewers to experience a wide range of spaces by "deconstructing the compressed space and time of photography and reorganizing them in three dimensions." In this regard, Koh Myungkeun has explained that while he approaches photography with seriousness, he remains somewhat liberated from the traditional definitions of its essence. This may explain why the spaces infused with a sense of tangible reality through his use of photography appear to have a greater expansiveness. This creates a feeling that they are "borrowed landscapes," offering a dynamic depiction of life's scenes.

When layering images in his photographic sculptures, he emphasizes his intent to help viewers sense the depth of space concealed behind the images within the confined dimensions. According to the artist, this paradoxically conveys the idea that "the world is nothing but an image." By using images of tangible reality as a medium, he employs transparent space to highlight the concept of "emptiness." In this context, it can be inferred that the artist aims to express the emptiness of existence through his transparent photographic sculptures. We are all inherently tied to the abstract concept of spacetime, and it is undeniable that we are constantly evolving within it. Consequently, perceptive viewers will quickly recognize that the artist's transparent sculptures are merely empty scenes, purposefully devoid of any intrinsic essence.

On the other hand, although most of the photographic sculptures stand at around 1 meter tall, the narratives they encapsulate within their spaces are immense. They unfold like a sweeping panorama, spanning historical artifacts and timeless ruins, everyday scenes shaped by people from diverse cultures, and even mysterious natural phenomena represented by the artist in shades of blue.

These narratives resemble imprints that resonate with the artist's memories and daily experiences. Within the image-filled space, viewers bring their own memories into the present, freely navigating the intersections between their perceptions and the visuals. The "transparent empty space" becomes imbued with new meanings as it absorbs the viewers' gaze, transforming into a crossroads where the artist's lingering moments and memories are shared.ⓚ

Combine Photography with three-dimensionality : Koh Myungkeun

An empty transparent film structure with water: Images overlap and shift depending on the viewing angle.

Q. How do you see the relationship between photography and sculpture?

In the late 1980s, I went to New York to study art. Having earned a B.A. in Sculpture in Korea, I wanted to explore other creative disciplines, so I enrolled in courses on photography, film, and design. During this time, I became deeply fascinated by photography as both a medium and a genre. I found myself taking more photography classes than those related to my original major. One day, it all began with a simple idea: what if I combined my two favorite genres, photography and sculpture? I started with the basics — printing photographs on paper, layering them with plaster, and incorporating wooden structures.

Q. How would you describe yourself as an image capturer?

In the past, I gravitated toward intricate, sculptural forms. However, the core message I sought to convey was that "the world is an image," akin to the Buddhist notion that "the world consists of shadows." To articulate this idea with greater clarity, I thought that too much structure could dilute the intended effect, so I designed a space with simple imagery to emphasize the notion of emptiness at its core. Even within narrow gaps, I aimed to create a visual depth that evoked a profound sense of emptiness. The work mainly focuses on buildings, nature, and humans, and I have to admit, I was quite ambitious with it. To achieve this, I captured each of these three elements separately through photography and developed my projects around them.

Q. What do you intend to communicate through empty spaces and photographic sculptures?

My goal isn't to direct the audience to the simple conclusion that "the world is empty." Any interpretation they form is entirely valid. I believe an art piece is successful when it encourages viewers to engage their imagination and personal narratives. Instead of delivering a fixed narrative, I aim to spark curiosity and invite the audience to explore various perspectives.

Q. What types of archival images (photos) do you plan to select for your next project?

These days, I'm looking for archived photos with vibrant colors among the many options available. Up to this point, I haven't focused much on incorporating chromatic hues in my work. However, I've recently come to realize that color has a significant emotional impact and conveys meaning, just as much as form or content within an image. Consequently, I am exploring the use of colors like yellow and red, along with other primary tones, integrating them into the core themes of my work.

Who is Koh Myungkeun?

Born in 1964, he obtained a B.A. in Sculpture from Seoul National University and later received an MFA from Pratt Institute. Since the late 1980s, he has been at the forefront of developing a unique genre known as "photographic sculpture," merging sculptural exploration with photography which showcases his distinct creativity. Since his debut solo exhibitions at Higgins Hall Gallery (New York) and Boyoon Gallery in 1991, Koh Myungkeun has showcased his work in over 20 solo exhibitions. These include notable venues such as the Kumho Museum of Art in 1993, OK Harris Gallery (New York) in 2007, Louis Vuitton (Taiwan) in 2010, the Museum of Photography in 2020, and the Savina Museum of Art in 2023. He has also contributed to prominent group exhibitions, including Youth Exploration Exhibition at the National Museum of Modern and Contemporary Art in 1994, Alienation and Assimilation at the Museum of Contemporary Photography in Chicago in 1998, Re-presenting Representation VII at the Arnot Art Museum in New York in 2005, Moon Generation at the Saatchi Gallery in London in 2009, and An Exploration of Korean Contemporary Photography at the National Taiwan Museum of Fine Arts in 2010.

Please scan the QR code to watch the sculptor's interview video.

KINETIC

Reflecting on Technological Civilization Through Mechanical Life Forms :
Choe U-ram

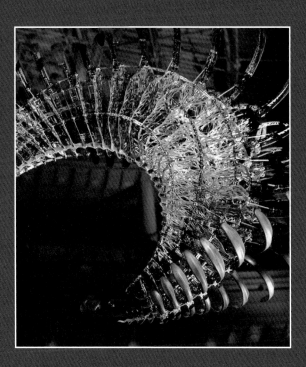

Acknowledging the uncertainty of losing direction without knowing the way forward,
exploring possibilities with hope intact, and restoring one's faith in humanity despite its
role in its own downfall, believing that it will ultimately find its own answers.
This is the journey that both humans and machines, now deeply intertwined, are meant to
take. Furthermore, it embodies the concept of salvation conveyed through
Choe U-ram's kinetic sculptures.

Mun Hyejin / Art critic

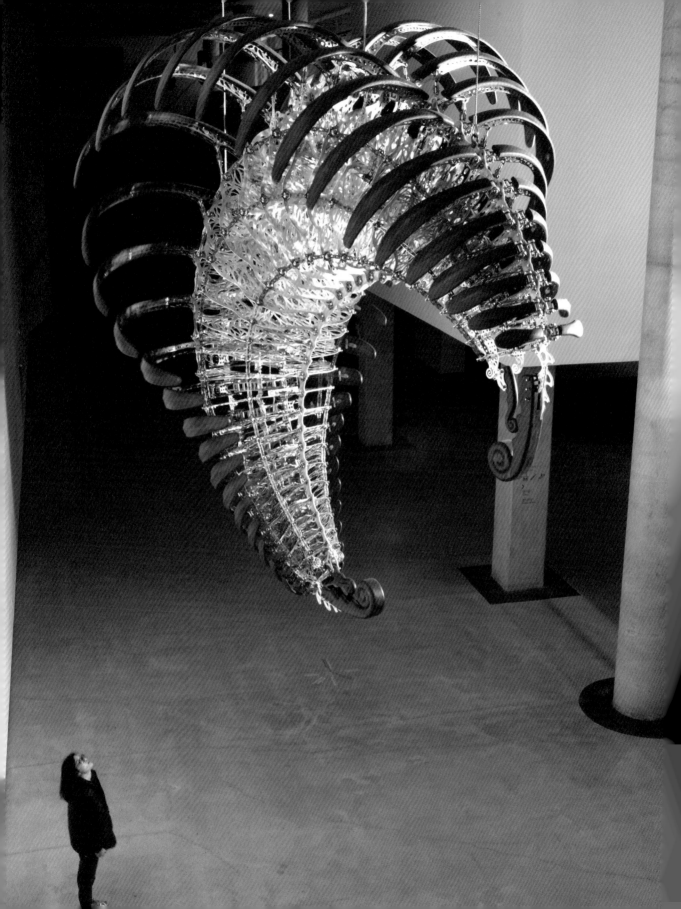

A childhood painting that Choe U-ram co-created with his father is particularly fascinating, as it seems to hint at his future artistic trajectory. The robots depicted in the painting, equipped with digestive systems akin to those of living organisms — capable of transforming consumed matter into energy — prefigured Choe U-ram's signature *Anima Machines*, mechanical life forms. Additionally, these robots functioned as an ark, designed to transport family and friends to safety in times of crisis.

Kinetic Sculpture – The Evolution into Artificial Life

The boy, who initially had a deep fascination with machines, began creating works where "machines come to life through the element of movement." This theme originated from a course on movement that he took during his undergraduate studies as a sculpture major. The artist imagined small, weaponized life forms emerging spontaneously in the city's unnoticed underground spaces, evolving by absorbing the residual energy from industrial activities.

Opertus Lunula Umbra
(Hidden Shadow of Moon)

Scientific name: Anmopial
Pennatus lunula U-ram
500×490×360cm /
Aluminum, stainless steel, plastic,
electrical devices (BLDC Motor
Motion Computing System) /
2008

The audience, mesmerized by the movement of the crab-like nanomachine *Mobius Syndrome* (1998), alludes to Choe U-ram's future path, where machines begin to resemble natural organisms. Despite its clearly inanimate, metallic

Little Ark

Installation view / 2022 /
Photo by Jeong Jihyun /
Courtesy of the National Museum
of Modern and Contemporary Art

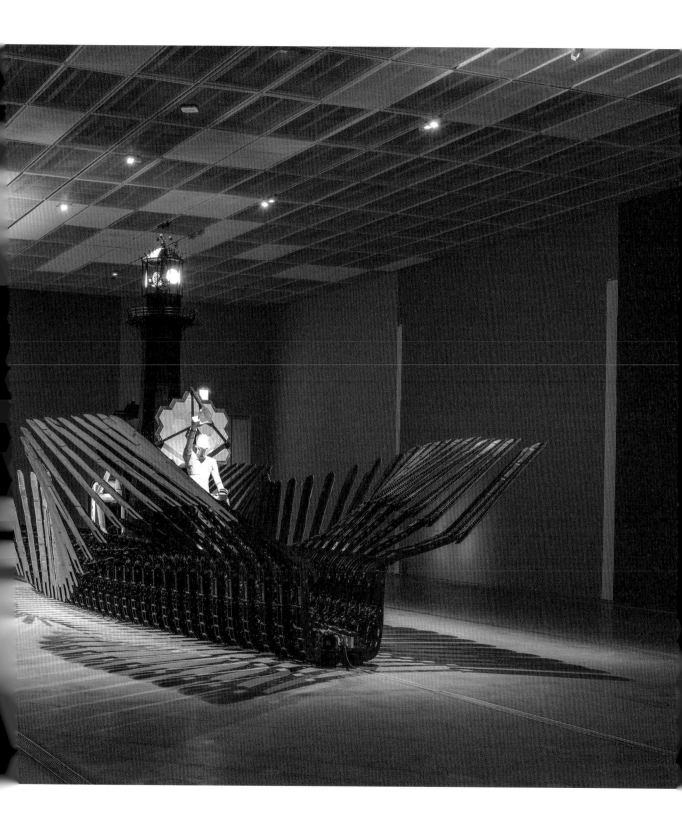

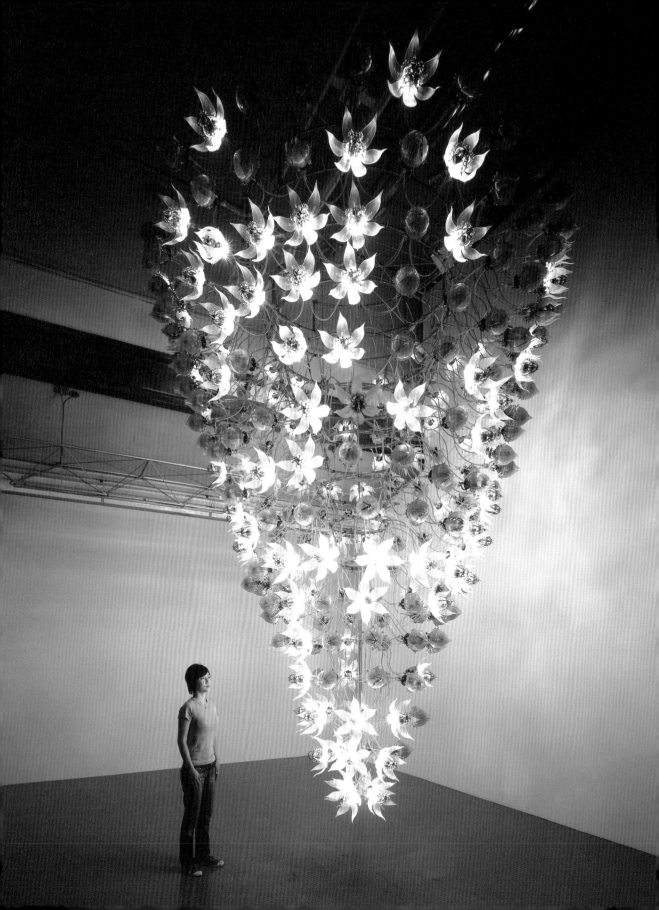

form, the machine seems to be alive due to its natural movements, akin to those of living creatures, and through light, which symbolizes life itself.

Choe U-ram's pseudo-organisms are inspired by real living creatures, both in form and function, transcending simple imitation of nature into genuine artificial life. The artist blends the motion of jet engines with shark teeth to craft a machine-animal hybrid (*Jet Hiatus*, 2004), and at times fuses barnacles with flowers to form an animal-plant hybrid (*Una Lumino*, 2008).

Furthermore, these quasi-life forms establish ecosystems where adults, larvae, females, and males coexist harmoniously (*Urbanus* series, 2006), or they symbolize virtual colonies of mechanical life forms that interact and thrive in groups (*Una Lumino*). This allows them to gradually develop into an autonomous natural order from individual components. Using the term coined by scientist Christopher Langton, these mechanical life forms broaden the concept of life, extending it from "a life we know" to "a life as it might become."

The concept of "a life as it might become" is realized across multiple dimensions. The fusion of machines and living organisms is evident not only in the subject matter

Una Lumino

Scientific Name : Anmopispl
Avearium cirripedia Uram
Metallic material, motor, LED, CPU
board, polycarbonate
520(h)×430(w)×430(d)cm /
2008

of the works inspired by animals and plants, but also in their intricate structures, movement designs, operational principles focused on efficiency, and the goal of creating artificial life.

One example is *Opertus Lunula Umbra* (2008), a piece exhibited at the Liverpool Biennale that brought Choe U-ram international recognition. This mechanical life form, resembling a massive caterpillar or arthropod, performs a rhythmic dance as it opens and closes its 29 pairs of wings. The movement, reminiscent of trembling ribs or the unfolding exoskeletons of crustaceans, is brought to life by more than 5,000 custom-made constituents made from over two hundred distinct kinds of components.

What sets Choe U-ram's mechanical life forms apart from other kinetic sculptures is their intricate and fluid movements, along with the beauty of their structure and fine details. The graceful metal framework of *Opertus Lunula Umbra* evokes the style of Art Nouveau — an innovative artistic movement in architecture, crafts, and painting that emerged in France from the late 19th to early 20th century, characterized by curved plant-inspired motifs.

Urbanus series

Installation view at the Mori Art Museum in Tokyo / 2006 / Photo by Kioku Keizo

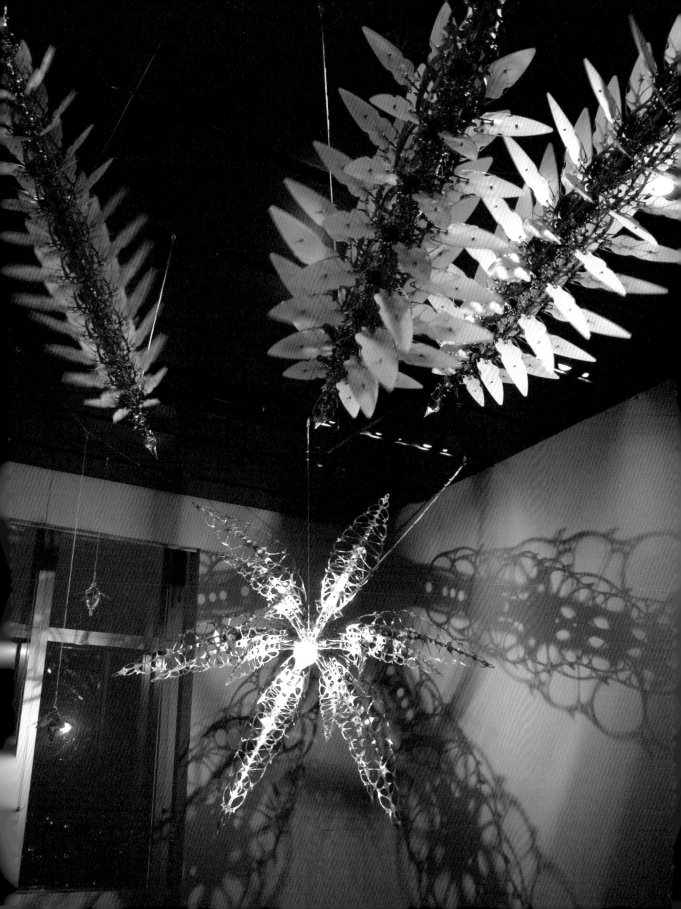

As the audience watches the layers of thin metal plates arranged in a manner reminiscent of leaf veins or flame patterns, they are struck by the beauty of the decorative designs.

Art Nouveau, famous for its vine-like motifs, incorporates organic structures inspired by nature. By working with malleable metal, it turns the delicate curves of plants into abstract forms, successfully blending material, structure, and expression in a tuneful way.

Choe U-ram's work aligns with Art Nouveau in the way it fuses handcrafted ornamentation and the mechanical elegance of metal with organic forms. However, beyond mere visual resemblance, his mechanical life forms embody the essence of Art Nouveau by integrating structure and function. While often mistaken as purely decorative, Art Nouveau's aesthetic is deeply connected to functional consensus, sharing qualities with mechanical design aesthetics.

Structures designed for function and purpose also serve a decorative role. This rationality, where form and function are seamlessly integrated, is a fundamental principle in Choe U-ram's work, evident not only in the appearance but also in the movement of his creations. The fusion of beauty and efficiency reflects a functionalist aesthetic rooted in

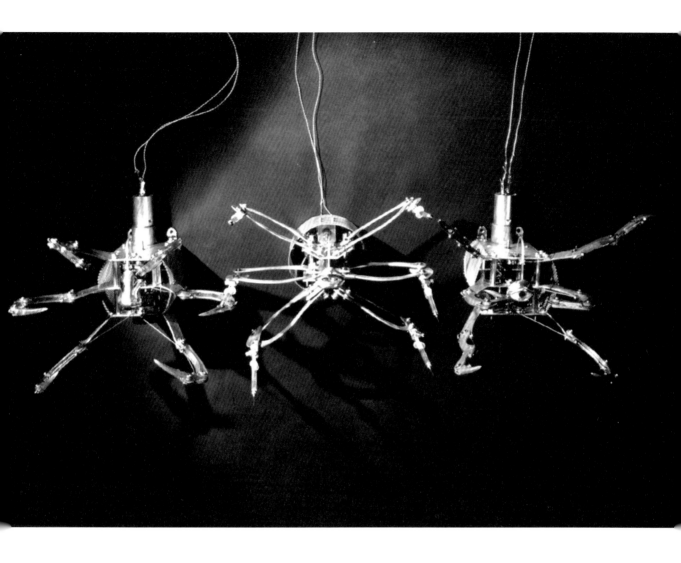

MOBIUS SYNDROME I, II, III

Scientific name : Apsoireal-ko
arthropoda-Uram
461 × 370 × 306mm /
mixed mediums / 1998

Reflecting on Technological Civilization Through Mechanical Life Forms: Choe U-ram

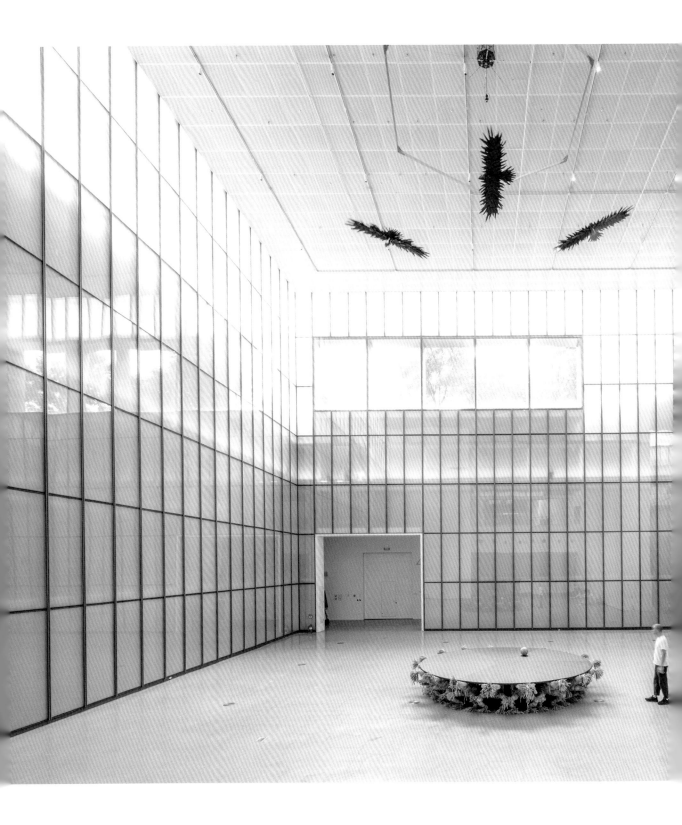

Round Table

Aluminum, artificial straw,
machinery, motion capture
camera, electrical devices
110(h)×450(w)×450(d)cm / 2022

Black Birds

Recycled cardboard boxes,
metallic material, motor,
machinery, electrical devices
dimensions variable / 2022

Photo by Jung Jihyun, Courtesy of
the MMCA

the biological principles of animal life. When accompanied by pseudo-scientific names, ecological reports, and creation myths, these mechanical life forms move even closer to embodying "a life as it might become."

Narrative Infused in Mechanical Life Forms

Until the 2010s, Choe U-ram's mechanical life forms multiplied and evolved in various directions. Along the way, he also explored new creative avenues. Notable works, such as the wire-formed dark angel *Scarecrows* (2012) and the architectural structure made of floating plastic bags *Pavilion* (2012), extended beyond the realm of artificial life forms. These pieces serve as a critique of the futile nature of technological civilization and human desires.

Choe U-ram's shift in artistic direction was signaled by *Little Ark* and *Round Table*, both presented as part of the MMCA Hyundai Motor Project in 2022. While these works remain within the realm of kinetic sculpture, they do not relate to living organisms. The elegant and decorative metalwork typical of his earlier pieces is minimal, and instead, materials like recycled cardboard boxes and synthetic straws are used, marking a departure from his previous choices.

Instead of the metaphor of living organisms, a narrative takes its place. Both works embody the artist's contemplation on human desires, influenced by technological progress and the chaotic state humanity currently endures. The vertiginous rise of automation, the relentless force of capitalism, and the onset of COVID-19 — which paralyzed the globe to an extent likened to the Black Death — have raised profound concerns about the future of humanity. Where are we headed on this planet? What direction are we meant to move toward?

The ark represents a sanctuary that will shield us from imminent peril. However, it also serves as a symbol of technological civilization, the path of which remains uncertain. With its symmetrical design, the two captains facing opposite directions, and the fragile materials crafted from recycled cardboard, the structure aims to convey the disorientation of the present and the futility of insatiable desires.

Round Table also represents the vainness of endless competition. On the ground, headless figures desperately fight to tilt the disc in a struggle to claim the heads. Similar to Sisyphus, the exhausted scarecrows engage in the grueling task of lifting the round table without rest. This act symbolizes modern individuals trapped in the limitations of the system, unable to break free.

Are their actions part of an internal complicity that reinforces the system, or do they represent a sacrifice to the oppression of the system? The artist's focus, which once centered on crafting quasi-living beings, has now broadened into a philosophical contemplation about the future direction of technological civilization as a whole, extending beyond individual entities.

At the core of change, there is also a sense of continuity. Both works carry forward the machine aesthetics where art and engineering converge, but in a more enhanced form.

For instance, in *Little Ark*, the grand choreography of 70 oars over a span of 20 minutes exudes a majestic power, reminiscent of a giant golden eagle spreading its wings. Unlike previous works, where a single motor controlled the movement, *Little Ark* features two motors on each unit (mechanical arm) with distinct operating ranges, enabling a dynamic movement that surpasses anything seen in earlier pieces.

Round Table (Close-up)

110×450×450cm /
Aluminum, synthetic straws,
mechanical devices, motion
capture camera, electrical devices /
Installation view / 2022 /
Photo by Jeong Jihyun /
Courtesy of the MMCA

Moreover, to avoid collisions between the units on either side, a simulator was employed to design the model, and errors were decreased through trial runs. This method represents a transition from the traditional hardware-focused approach in mechanical engineering to a greater reliance on software-driven control and measurement.

The engineering advancements result in a significant aesthetic transformation. The grand narrative of humanity, trapped in the relentless rush of material civilization and facing a deadlock, yet ultimately redeeming itself through human determination, is expressed through innovative forms of movement — subtle and varied, embracing asymmetry, and incorporating pauses.

The pure good intentions of designing escape robots reemerges once more. Acknowledging the uncertainty of losing direction without knowing the way forward, exploring possibilities with hope intact, and restoring the faith that humanity, despite its role in its own downfall, will ultimately find its own answers. This is the journey that both humans and machines, now deeply intertwined, are meant to take. Furthermore, it embodies the concept of salvation conveyed through Choe U-ram's kinetic sculptures.🅺🅂

A Sculptor of Mechanical Lifeforms : Choe U-Ram

Creating artworks applying mechanical devices, lighting, sound, and performance to bring the artist's envisioned scenes to life

Q. **What inspired you to create mechanical lifeforms and kinetic sculptures?**

Artists have various ways to express themselves. Utilizing machines for movement, incorporating light, adding sound, or conveying ideas through video works... These various media became integral to my art because the images in my mind were never static; they were constantly in motion. They respond to environmental shifts and evolve over time, unfolding like a performance. While these ideas could be represented through static sculptures or paintings, I prefer an approach that fully immerses the audience in all these elements. That's why I aim to integrate as many of these aspects as possible into the exhibition space.

Each piece I create has a unique concept, form, and set of required techniques, making it challenging as some works take over a year to complete. Even after a year of creation, exhibiting the work often highlights aspects that can be improved. I then keep refining it over time, sometimes spending three to four years before deeming it truly finished. The same applies to a commercial product. It doesn't enter the world as a flawlessly designed final version from the beginning. It undergoes trials, testing, and refinements, where even a minor adjustment can significantly enhance its performance. This is one of the challenges I encounter in my creative work. However, navigating these aspects is also part of what I enjoy, so I am continually engaged in this process.

I showcased a piece at the Daejeon Biennale that depicted a single entity dividing into two. The concept explores technology, particularly artificial intelligence. As AI advances, it may bring benefits to some while potentially having adverse effects on others. It's similar to the release of an unfamiliar, strange life form into the world — one that remains within an undefined boundary. In this context, depending on how it is applied, vastly different futures could unfold. The In this context, the way it is applied could lead to vastly different futures. The artwork conveying this concept is currently on display at the Daejeon Museum of Art. Since our minds do not possess vast databases, we have created external systems and machines that can reason within them, effectively replacing certain human capabilities. If we don't carefully address this issue now, the consequences could be as momentous

as when the atomic bomb was first invented. This topic is deeply connected to the peaceful, harmonious world I envisioned as a child, so I am reflecting on how to explore these questions through my artwork.

Q. Which of your works do you cherish the most?

The piece I cherish the most is always the one I am currently working on. No matter what it is, my deepest connection is with the creation in progress. Once a work is finished, my fondness naturally shifts to the next project. In that sense, instead of forming a personal attachment to my past works, my bond with them grows through the audience and my studio colleagues.

Who is Choe U-ram?

Choe U-ram, born in 1970 in Seoul, holds both a Bachelor's and Master's degree in Sculpture from the College of Fine Arts at Chung-Ang University. From the early days of his career, he has been inquiring into the meaning and potential of integrating movement into visual art, blending his unique fascination with machines and sculpture to create kinetic sculptures. In his work, movement transcends simple motion or activity, serving as a manifestation of life itself, which has inspired his ongoing series *Mechanical Life Form*.

Choe U-ram's kinetic sculptures quickly earned recognition for their remarkable technical prowess and level of completion. His invitation to the inaugural exhibition at the Leeum Museum of Art in 2004 marked the beginning of his recognition as one of South Korea's leading artists. In 2006, gained international acclaim with a solo exhibition at the Mori Art Museum in Tokyo and his participation in the 6th Shanghai Biennale that same year.

In 2008, Choe U-ram showcased his signature works *Una Lumino* and *Opertus Lunula Umbra* at solo exhibitions in Tokyo's SCAI The Bathhouse and the Liverpool Biennale. By 2011, he had solidified his reputation as a global artist with a solo exhibition at the Asia Society Museum in New York. Later, in 2017, he presented a major solo exhibition at the National Taiwan Museum of Fine Arts. In 2022, he was selected as the featured artist for *the MMCA Hyundai Motor Series 2022*, holding a solo exhibition at the National Museum of Modern and Contemporary Art.

Choe U-ram's works are part of renowned art collections both in South Korea and abroad, including the National Museum of Modern and Contemporary Art, Seoul Museum of Art, Daegu Art Museum, SOMA Museum of Art, Leeum Museum of Art, Amorepacific Museum of Art, POSCO Art Museum, the Newark Museum of Art in the USA, Art Stations Foundation in Poland, Shanghai Youth Arts Foundation, and Borusan Contemporary in Istanbul. He has received several prestigious awards, including the Grand Prize at the 1st POSCO Steel Art Award in 2006, the Kim Sechoong Sculpture Award in 2009, Today's Young Artist Award from the Ministry of Culture, Sports and Tourism in 2009, and the Artist Award at the Monthly Art Awards in 2024.

Please scan the QR code to watch the sculptor's interview video.

EXCAVATION

Archaeological Landscapes Excavating the Memory of Creation and Dissolution:
Cha Kiyoul

Cha Kiyoul's excavation project is reminiscent of the work of archaeologists in that it involves delicately brushing away layers of strata one by one. However, he becomes deeply absorbed in the energy that moves through the exposed floor-stone slabs and the rafters of a hanok, a traditional Korean house. He keenly observes how presence and absence intertwine within this space, flowing together in a tuneful rhythm.

Peik Kiyoung / Former Director of Operations at Buk-Seoul Museum of Art

Urban Excavation –
Archaeology of Lives 2022-2007

Mixed media / 2023

Wadong - cha 2

g - cha 28

Wadong - cha 1

Excavation Project-Hyungdo 2015

Discovered object / 2015

Archaeological Landscapes Excavating the Memory of Creation and Dissolution : Cha Kiyoul

Cha Kiyoul has primarily engaged in installation art, integrating natural elements and archaeological artifacts while exploring themes of nature's cycles and civilization. His artistic journey began in the 1980s with paintings and objects. In the 1990s, he shifted toward religious and environmental themes, employing natural materials. By the 2000s, his practice had evolved further, encompassing earth art and performative body art, incorporating materials like wood and stone, as well as experiences gained from his own travels to remote regions.

Through his comprehensive work, without limiting himself to a specific medium, Cha Kiyoul explores the path of all life that has existed on the nurturing earth, which he views as the fundamental source and origin of existence. To him, the earth is both the cause and the archive of life's boundless phenomena. Using materials sourced from the earth, he creates his works while attuning himself to the sounds emanating from the land, engaging his body as it moves through the land.

The artist's involvement in an archaeological excavation project began with *Urban Excavation – Archaeology of Lives*, which took place in Tongui-dong, Seoul, in 2007. This initial project paved the way for a series of ongoing excavation projects: *The Bunhyang-ri Excavation* (2009),

Excavation Project-Hyungdo 2015

Discovered object / 2015

Archaeological Landscape -
Mandala of Fire

Plasticited mudflats / 2023

where the artist unearthed the site of his childhood home;" *The Baedari Excavation* (2009) in Incheon, which revealed traces of modern culture from the port-opening era; and *Hyungdo* (2010), conducted on an island that was once sea but had been transformed into land through reclamation. In 2014, the *Juandong* project involved excavating the floor of a house at 1342-36 Juandong, the location of Space Dum. The most recent project in this series is the *Wadong Branch School* (2021) project in Hongcheon, undertaken as part of the Gangwon Biennale's invitational program.

Excavated Landscapes, Circulating Memories

Cha Kiyoul's excavation project is reminiscent of the work of archaeologists in that it involves delicately brushing away layers of strata one by one.

During the excavation, reference lines are set at regular intervals, and the artifacts discovered within them are photographed and recorded in excavation journals. While the earth fosters life, archaeology seeks to trace the history of death rather than focusing on life itself.

At the excavation site beneath the floor of the traditional hanok in Tongui-dong, traces of the people who once lived there were uncovered. The artist brought together all his historical knowledge, aware that this location had

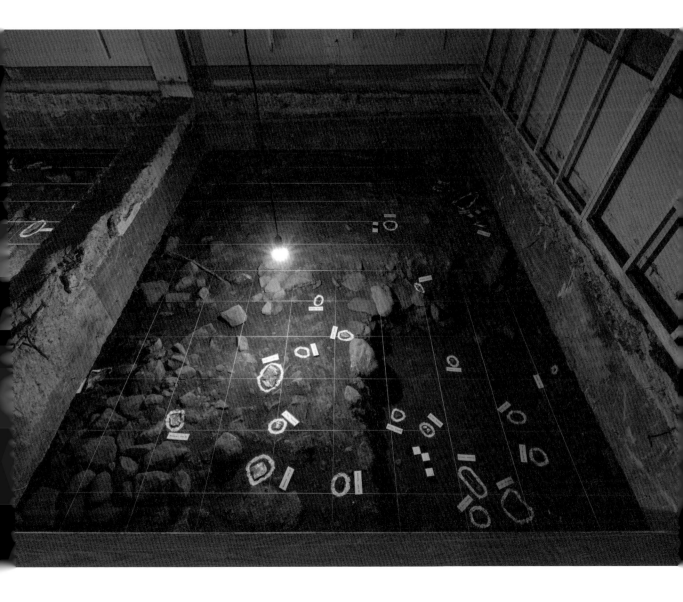

Archaeology of Lives -
Wadongri 275

On-site excavation, Mixed media

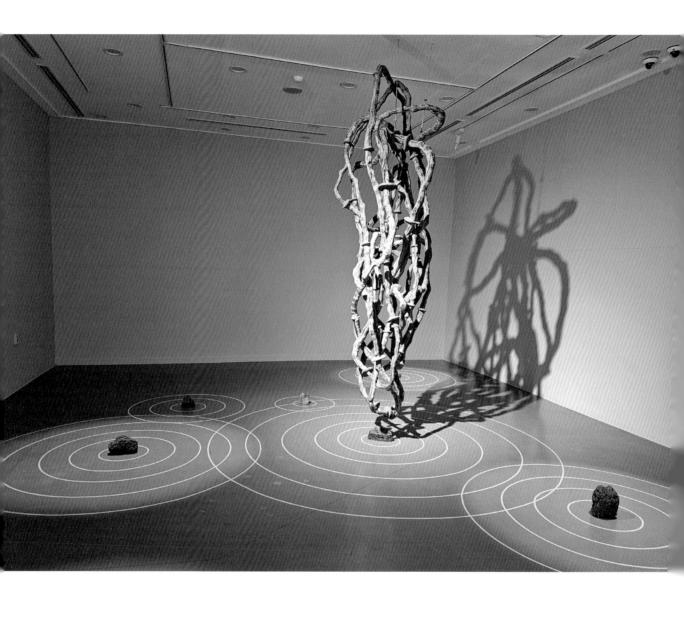

The Journey of Circulation-
A Period Between Ark & Kangmok

Variable Installation /
Grapevine, Stone / 2024

been the site of Changuigung Palace and later the home of the Oriental Development Company during the Japanese occupation. Had he been an archaeologist, he would have further explored the historical archives for more in-depth insights. However, he becomes deeply absorbed in the energy that moves through the exposed floor-stone slabs and the rafters of a hanok, a traditional Korean house. He keenly observes how presence and absence intertwine within this space, flowing together in a tuneful rhythm.

In his artist's statement, he expressed, "The movement of intertwined lines intersects with the lines of the drawing, simultaneously expanding its volume. It fosters organic processes of growth and disappearance. The space, extending from the floor to the walls and ceiling, is shaped by a steady rhythm that balances tightness and looseness, filling and emptying."

Instead of considering the artifacts unearthed through excavation as the ultimate goal, Cha Kiyoul's focus shifted to other elements of the space uncovered during the process. The fact that he later coined the term "archaeological landscapes" suggests that, for the artist, archaeology is more about a "discovered landscape" or a "processual performance" than a final outcome. This is a natural extension of the artist's long-held desire to

create art that reflects a world shaped by the cycle of life and death. Cha Kiyoul traces this inclination back to his childhood memories of digging in a corner of the yard.

These site-specific, quasi-archaeological excavation projects are structured like a research endeavor, similar to an academic pursuit. For the artist, archaeology serves as a means to explore the memories of both individuals and communities. In his excavation projects, archaeology is not viewed as the outcome of an elaborate construction of historical knowledge. Instead, it is seen as a method for aesthetically analyzing the objects uncovered during the excavation, aligning with a psychoanalytic approach to interpret the memories that these objects evoke.

Excavating Myself, as the Form of Material and Life

Over time, Cha Kiyoul's excavation projects transformed into both spatial installations and performative spaces. The objects unearthed were exhibited in showcases alongside detailed drawings. The environments in which he worked also grew more varied. From the site of his childhood home to outdoor locations and abandoned schools, any place on which he stood became a possible excavation site, serving as a matrix filled with countless stories.

The Journey of Circulation-
A Period Between Ark & Kangmok

Grapevine, Stone, Water, Steel /
2015

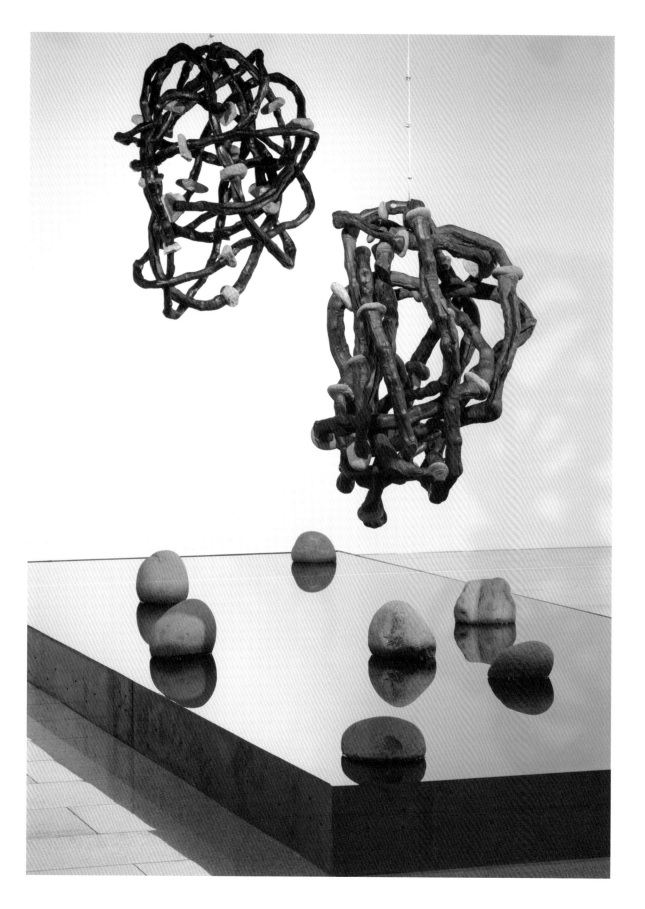

The Journey of Circulation-
A Period Between Ark & Kangmok

Variable Installation /
Grapevine, Moss / 2023

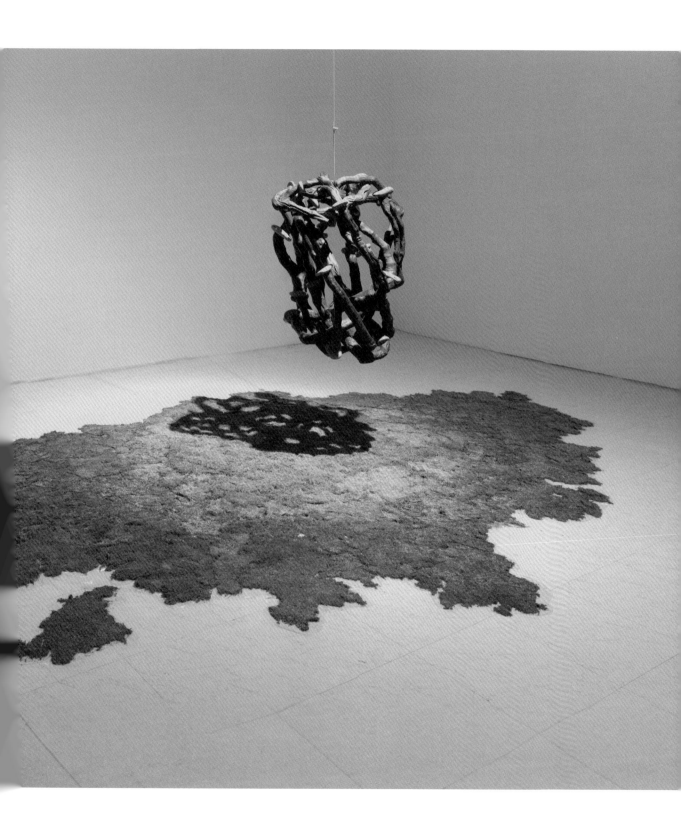

Reflecting on art historian Kim Mikyung's description of the earth and soil in Cha Kiyoul's work as "the womb of the mind," for the artist, the earth and soil may symbolize "the memory of the world" and "the mother of all nature." The artist broadened his imagination by traveling across various places.

The Tongui-dong Urban Excavation, which examined the perpetual cycle of life and death through the excavation process, reached another pivotal moment with *the Archaeological Excavation – Hyungdo project* (2015). Hyungdo is a region where an island was converted into land following the construction of the Shihwa Seawall.

In this area, fossilized dinosaur eggs were discovered underwater, leading to the designation of Hwaseong Geopark as a UNESCO World Natural Heritage site. Cha Kiyoul's excavation project naturally shifts away from the residential spaces of old urban areas, where human civilization once thrived, and instead engages with a geological imagination that preserves ecological records dating back tens of thousands of years.

This excavation project had to dig deep into the core of material imagination, exploring marine organisms that create fractures on the hardened tidal flat surfaces and the white, powdery salt crystals that emerge as moisture evaporates. The soil's surface is dotted with holes formed by marine creatures. Where the creatures have built up their homes, the artist excavates these to reveal hidden objects. Within the imaginative dimension of this space, destruction and creation coexist simultaneously.

Here, Cha Kiyoul advances his exploration with *Archaeological Landscape – Mandala of Fire* (2018), a project that involves firing tidal flat soil for molding. Presented as an installation at the Woori Museum of Art in Manseok-dong, Incheon, this work evokes scenes of marine creatures constructing their homes, a familiar sight on the tidal flats of the west coast. The terracotta, solidified in the intense heat of the kiln, serves as a testament to activities of life, encapsulating the cyclical flow of existence in a mandala-like form. The word "Mandala" originates from Sanskrit, the ancient language of India, and signifies both "circle" and "center." Etymologically, it is derived from "Mandal," which means essence, and "La," which refers to possession. Essentially, the term "mandala" is commonly associated with spiritual practices that seek to attain truth by reaching a state of centeredness and essence.

In this context, the earth becomes an object of molding rather than excavation. Just as Cha Kiyoul once used stone and wood as "discovered objects," the tidal flat is transformed through fire into a "discovered object" in the process of molding.

The conversion of the soft, water-laden mudflats into terracotta mirrors an alchemical transformation. The dark mudflats are transformed into reddish terracotta within the kiln. Embedded within these clay pieces are the preserved marks of marine creatures' playful constructions in the tidal flats. In this process, the artist serves as the latest earthly being to transform the soil.

Cha Kiyoul questions, "Would surrendering our sense of dominance over materials and positioning ourselves as one with the foundational elements have made art more meaningful to humanity? Amid the classifications of Kingdom-Phylum-Class-Order-Family-Genus-Species, where do we aim to place ourselves? Sitting by the river, observing a stone, I contemplate the final destination of the Odyssey that humanity is meant to journey toward."

His contemplation of material enables him to recognize himself as both a living being and as matter itself. Throughout history, the world has served as the source of human imagination and the origin of enlightenment. The artist reflects, "Just as water flows in its natural course, fragments from the moments of history also flow continuously, in unison with time, and reaching the present." Isn't this ancient wisdom true? "The highest good is like water."🅖

An Artist who Excavates and Installs Memories : Cha Kiyoul

Conducting an experiment with mixed media by blending drawing, painting, sculpture, and installation

Q. Why do you choose natural materials for your art?

Growing up in an environment rich with tidal flats, I was constantly drawn to create art, as if receiving a message from my surroundings. I believe these natural elements will remain at the core of my future creations.

Q. What inspired you to begin an archaeological excavation project?

I am currently working on two projects: *The Journey of Circulation* and *Urban Excavation*. There are several reasons why I embarked on these projects. I had the opportunity to participate in an archaeology forum, where there was an annual art project linked to archaeology. During one of these projects, an Acheulean hand axe was discovered. This was a significant find, as it had

never been discovered in East Asia before. It is one of the finest examples of chipped stone tools and served as proof that such a culture once existed in the region. Through that project, I developed a keen interest in archaeology. It wasn't the historical content that captivated me, but rather the installation-like aspect of the excavation process. I began to wonder how I could connect this with other narratives. What kind of lives did ordinary people live? Their memories, layered over time, eventually formed the history of families, which then led to the development of societies and even nations. We have always emphasized things considered valuable and meaningful. However, history is also shaped by layers of triviality. I wanted to examine this aspect more closely - triviality. Since 2007, I have been conducting excavation projects by choosing specific sites like ordinary homes, abandoned urban houses, and places with personal connections to me.

Q. What message does *The Journey of Circulation – A Period Between Ark and Kangmok* convey?

The piece serves as a warning against human arrogance, pride, and the attitudes we adopt as biological beings in the face of the current global situation. Essentially, *The Journey of Circulation* explores the idea of cycling, based on the notion that everything in existence circulates and never truly breaks. The concept behind "Between Ark and Kangmok" is straightforward, with "Ark" referring to Noah's Ark. The term "Kangmok" or "Gangmu" is derived from *Bencao Gangmu (The Compendium of Materia Medica)*, authored by Li Shizhen during the 16th-century Ming dynasty in China. By referencing *Bencao Gangmu*, I incorporate Asian philosophy. What lies between Western thought and Asian values? At their core, they share similarities, both addressing life. The division between East and West is a human construct. The Earth itself never

created such a separation, nor did we define it that way. These divisions were made for human purposes. There must be an essential thread linking the spirit of Asia and the spirit of the West. The value is: What should we pursue in life? My work aims to explore answers to this question. In this process, I typically avoid altering what nature has predetermined. Instead, I present it as it is, adding only a slight touch of my own perspective. When incorporating nature's inherent power into a white cube, I feel the need to establish a specific form of presentation. However, when I showcase an art piece, I never assert that "this" is the definitive theme. Instead, I pose the question: "What do you think of this?"

Q. What current installations and projects are you working on?

I am currently planning a project that traverses the West Sea, from Baengnyeongdo to Yeosu. The exact locations are not yet finalized. This project will be conducted through the "Salt Land Archive" and is expected to take around 3 to 5 years to complete. Once finished, I plan to publish a book and hold a large-scale exhibition.

Who is Cha Kiyoul?

Cha Kiyoul earned both his B.A. and M.A. in Painting from Incheon National University, where he is currently a professor in the Department of Fine Arts. His interdisciplinary works across painting, drawing, objects, and installations explore themes related to the earth's natural cycles and the organic processes of creation and destruction. Since the 1990s and into the 2000s, Cha Kiyoul has pursued his artistic practice through themes such as "Floating Souls," "Memories of the Earth," "Room of Contemplation," and "Journey of Circulation." After his 2004 project at the Kookmin Art Gallery, he launched a project named *The Journey of Circulation - Between Ark and Kangmok*. Following the 2007 hanok excavation project in Tongui-dong, he expanded his work with *Urban Excavation – Archaeology of Lives* and, in 2018, *Archaeological Landscape – Mandala of Fire*.

Cha Kiyoul debuted with his first solo exhibition, *Floating Souls* (Dansung Gallery, 1992), and has since presented solo exhibitions in various locations, including Seoul, Incheon, Los Angeles, and Vermont. He has also taken part in major thematic exhibitions such as *Singing Land* (Busan), *An Observation of the Yellow Sea* (Incheon, 2023), and the *Incheon Peace Art Project* (2012–2013). Furthermore, he has been featured in international art events, including the Busan Biennale (2010), Gangwon Triennale (2021), and Geumgang Nature Art Biennale (2022). Starting with the Vermont Studio Center in the United States, Cha Kiyoul has participated in various residency programs since 2002. These include the National Changdong Residency (Generation 2, 2003), Haje Art-Space Residency (2004), and KunstDoc International Residency (2006). He also took part in the Nomadic Residency Program organized by the Arts Council Korea, which spanned multiple locations, including Mongolia, Jeju, and Australia. Cha Kiyoul's works are housed in esteemed collections such as the Park Sookeun Museum, Jeondeungsa Temple, Jeongok Prehistoric Museum, OCI Museum of Art, and the Ha Jungwoong Collection at the Gwangju Museum of Art. He has also been recognized with prestigious awards, including the Excellence Award at the 2000 Chungang Art Exhibition and the 7th Park Sookeun Art Prize in 2022.

Please scan the QR code to watch the sculptor's interview video.

Roundtable on the Future of K-Sculpture

Drawing Out the Discourse on "the Uniqueness of K-Sculpture"

PANELISTS

Kang Eunju / Art historian

Hong Kyounghan / Art critic

Choi Taeman / Professor at College of Arts of Kookmin University

Park Dongmi / Roundtable moderator & editor, Munhwa Ilbo Reporter

As the second season of *The Future of K-Sculpture Expanding Globally* concluded, a roundtable discussion took place on December 12, 2024, at Munhwa Ilbo in Jung-gu, Seoul. Art historian Kang Eunju, art critic Hong Kyounghan, and Choi Taeman, a professor at College of Arts of Kookmin University, convened to examine the current landscape of Korean sculpture and its future prospects. Looking back on the series, which featured 12 mid-career sculptors — recognized as the "backbone" of Korean sculpture — they commended the initiative for reaffirming the potential of K-Sculpture. The panel concurred that as digital technology continues to evolve, the increasing appreciation for analog values is also reflected in the art world. They further emphasized that

the distinctiveness and originality of Korean sculpture give it a strong competitive edge in 21st-century contemporary art. This series was a collaborative effort between Munhwa Ilbo and Crown Haitai. To enhance the discussion, Crown Haitai's Chair, Mr. Yoon Youngdal, was also in attendance.

Q. *The Future of K-Sculpture Expanding Globally* **has successfully wrapped up its second season. What are your overall thoughts on this series?**

<u>Kang Eunju, Art Historian (hereinafter, Kang)</u> I eagerly awaited each new article as soon as it was published. The phrase "backbone of Korean sculpture" aptly captured the essence of these works. I was deeply moved to see sculptors who had long deserved recognition finally being highlighted in a major newspaper. As someone engaged in the art world, I found this project both captivating and meaningful. It led me to continuously ponder, "What truly defines K-Sculpture?" Perhaps its significance lies in initiating a discourse on the distinctiveness of Korean sculpture.

<u>Hong Kyounghan, Art critic (hereinafter, Hong)</u> I found it fascinating how the 12 different critics each interpreted the 12 sculptors in their own unique ways. Just as every artist has a distinct approach to their work, the critics bring their own perspectives to their analyses. Although the descriptions of the artists' worlds and their artworks

are always valuable, this in-depth exploratory format made the series especially compelling. Both the sculptures and the writings conveyed a strong sense of individuality.

Choi Taeman, Professor at College of Arts of Kookmin University (hereinafter, Choi) Many believe that the identity of Korean sculpture is ambiguous. However, I think initiatives like this series project contribute to shaping that identity. Rather than aiming for a specific definition, the ongoing efforts will gradually unveil our unique identity, originality, and distinctiveness over time.

Q: What do you think "K-Sculpture" is? Does it indeed have a tangible, substantial identity?

Choi I believe that Korean sculpture is currently in a severe crisis. The number of university programs offering sculpture majors is dwindling. Also, the physically demanding nature of the work makes it less appealing. Additionally, the large scale and workspace requirements for sculpture create further challenges. Environmental art, a type of public art, has been one area keeping sculpture somewhat alive. However, even this field has declined in quality, as it now primarily focuses on satisfying popular taste. Given this context, should we let sculpture fade away with changing trends? Definitely not. Traditional sculpture possesses unique characteristics and appeal that will

endure. I view this series as an initiative to preserve and further develop the art form.

Kang In my opinion, defining the essence of K-Sculpture requires in-depth discussion. They say that crisis brings opportunity, and perhaps now is the time to seriously address the status of K-Sculpture. We should recall the Masters section at Frieze London last October, where a major exhibition showcased sculptures rooted in traditional techniques. Even as a commercial art fair, Frieze emphasized the materiality of sculpture and highlighted contemporary artists who adhere to classical methods. This demonstrates that the value of contemporary sculpture is widely recognized. Therefore, we need to put more effort into contemplating the tangible identity of K-sculpture.

Q. K-sculpture, which requires more discussion about its tangible identity: Does it genuinely have potential and hope?

Hong The sculpture scene is currently facing significant challenges, a reality acknowledged by those within and beyond the art world. The emergence of this project itself signals hope and potential. Both artists and critics are navigating difficult circumstances, and this series has offered them a valuable space for discussion. In an age dominated by new media, diversity, and pluralism,

sculptures that focus on materiality and traditional techniques are often overshadowed. However, since all innovation is rooted in tradition, it is crucial to reexamine and highlight these works. This perspective fosters more balanced comparisons and analyses between new media and traditional sculpture.

Choi Attempts to define something often end in failure. While Korean sculpture possesses "something" with a distinct quality, trying to articulate it theoretically may not always be persuasive. A recent example, however, offers significant hope — sculptor Kim Yunshin, who spent decades pursuing her artistic career in Argentina before returning to Korea, received widespread recognition through her homecoming exhibition. This success led to her participation in this year's Venice Biennale. Rooted in traditional sculptural techniques, her work made a profound impact on audiences. Isn't this an encouraging sign? It demonstrates that this genre called sculpture holds a unique and compelling allure.

Kang In this series, I delved into Yeesookyung and her artistic universe. Not only Yeesookyung but also female artists like Shin Meekyoung, known for her soap sculptures, seem to be stirring up a fresh wave in Korean sculpture. While contemporary artists cannot be confined

to a single category, many female artists within the realm of Korean sculpture — such as Suki Seokyeong Kang and Lee Mire — are at the forefront of experimenting with new materials and techniques. This signals a bright future not only for K-Sculpture but for Korean art as a whole.

Q. What immediate actions should be taken — whether in artistic practice, exhibitions, or policy-making — to ensure the future of K-Sculpture?

Kang Among the twelve featured sculptors, only two were female, highlighting a significant imbalance. This gap leaves much room for improvement. I hope to see more recognition for female sculptors actively working in both Korea and abroad. Although there are numerous sculpture-related events and exhibitions, truly captivating and engaging ones remain rare. Recently, Kim Yunshin, who returned from Argentina, has gained strong support from both art critics and the public. Organizing an exhibition dedicated to Korean female sculptors across different generations would be a meaningful endeavor — one that explores materiality and aesthetic form while offering a compelling perspective.

Hong The prevailing dominance of commercial art in Korea is unlikely to change easily, as reversing this trend would require immense effort. Given this reality, it is vital to place greater focus on sculptors who are dedicated to preserving the essence of sculpture, along with their artistic philosophies and perspectives, and to grant them the recognition they deserve. Moreover, sculpture is still often regarded merely as decoration. I hope to see a stronger emphasis on artists and works that engage with the social role of art. Art and artists serve as guiding lights and compasses within society, and within this framework, the potential of K-Sculpture can be further explored.

Choi Supporting artists and their work is essential, but ultimately, it is documentation that ensures their contributions are recognized and defined. In this regard, this series holds significant value. I hope to see greater support for researchers in the future as well. It is regrettable that only one book has systematically documented the history of modern Korean sculpture — and that it was published 15 years ago. Furthermore, efforts should be made to help people understand that sculpture is not just confined to museums or parks but is deeply connected to everyday life. This awareness can be fostered organically through writing, exhibitions, and publications.

Q. What recommendations would you offer for the third series to further promote and support K-Sculpture?

Hong The Munhwa Ilbo, Crown Haitai, and the critics who co-organized this series project form a temporary community committed to K-Sculpture. It would be valuable for this community to also consider the next steps. What I mean is that it would be wonderful if the project could continue supporting creative activities even beyond the publication of the series. For K-Sculpture to gain global recognition, the discourse shaped by critics will be indispensable. Developing related programs will also play a crucial role in this effort.

Choi The artists featured in Season 2 were relatively well-known. While this effectively helped promote K-Sculpture to the public, it lacked the thrill of discovery. For the third season, a clearer direction for the project would be beneficial. If discovery is not the focus, why not take an approach that reevaluates established sculptors? This could introduce fresh perspectives into the art world. Additionally, I hope the series serves as a platform for critical discourse that considers the present and future of K-Sculpture from a broader perspective.

Kang The series title includes the phrase "Expanding Globally," so why not make this concept more tangible? If the goal is to introduce K-Sculpture to international museums and galleries, producing English-language

catalogs would be important. Furthermore, the discussions within the series could become even more enriching by exploring how contemporary artists engage with traditional sculpture within the contexts of conceptual and three-dimensional art, as well as how they are pioneering new directions.

K-SCULPTURE III

The Future of K-Sculpture Expanding Globally 2

First edition, first printing published on March 25, 2025

Authors Kang Eunju, Kang Jaehyun, Kho Chunghwan, Kim Sungho, Kim Suejin, Kim Yoonsub, Kim Jinyub, Mun Hyejin, Peik Kiyoung, Lee Kyungmo, Choi Taeman, Hong Kyounghan
Publisher in charge Yoon Youngdal, Chair of the K-Sculpture Organizing Committee
Publisher The K-Sculpture Association

Planning So Sungsoo, Lee Seungjun
Publishing Agency I Rich Korea
Overall Responsibility Kim Malju
Editing Kim Gyeongsil
Design The Page Communication

Registration Date December 10, 2012
Registration Number 2012-000385
Address Hangang-daero 72-gil 3, Yongsan-gu, Seoul, Republic of Korea
Main Desk Phone 02-545-7058
Website www.k-sculpture.com

ISBN 978-89-98584-29-0 03620

MEMO

MEMO